STONE

STUDIES IN CONTINENTAL THOUGHT

John Sallis, *general editor*

CONSULTING EDITORS

STONE

John Sallis

Indiana University Press

Bloomington and Indianapolis

The paper used in this publication meets the minimum
requirements of American National Standard for Information
Sciences—Permanence of Paper for Printed Library Materials,
ANSI Z39.48-1984.

Manufactured in the United States of America

Library of Congress Cataloging-in-Publication Data

Sallis, John, date
 Stone / John Sallis.
 p. cm.—(Studies in continental thought)
 ISBN 0-253-35062-X (cloth).—ISBN 0-253-20888-2 (paper)
 1. Stone in art. 2. Arts—Philosophy. I. Title. II. Series.
NX65.S85S25 1994
700'.1—dc20 93-45307

1 2 3 4 5 99 98 97 96 95 94

For Nicholas and Benjamin

"Wir graben den Schacht von Babel"

—Franz Kafka

CONTENTS

LIST OF PHOTOGRAPHS

ACKNOWLEDGMENTS

FOR PERMISSION to reproduce photographs I would like to thank the Teylers Museum, Haarlem, The Netherlands (no. 4), Jürgen Winkler (no. 5), Jan Lukas (nos. 9–12), Hirmer Verlag (nos. 16–17, 24–27), Dr. Hans Peters Verlag (nos. 18–20), RCS Libri & Grandi Opere (no. 21), and the Chicago Historical Society (no. 30). Thanks also to my wife Jerry for several of the photographs. To Nancy Fedrow and Jeffrey Taylor I am grateful for help during preparation and production of the book.

Nashville
February 1994

STONE

1

SHINING TRUTH

I WOULD HAVE LIKED this discourse to be inscribed by a very skillful stonemason, by one who knew just the right slant at which to hold the chisel so as to cut obliquely into the stone and produce well-formed, clearly legible letters, chipping away the stone so as to leave the inscription both in place of stone and yet still in stone, practicing thus a kind of lithography. I would have liked the well-measured strokes of his hammer to be audible, as he practiced his venerable craft of making stone, in its silence, nonetheless speak. As when, more than a thousand years ago in Pra Pathom Chedi, some-one—his name forgotten, long since dead and gone—struck the huge stone bell that now hangs silently in the National Museum in Bangkok. As if a stroke of that bell, the sounding of its stone, were to announce and open a spectacle in which all that is said of stone would be said in stone, by stone itself, drawn from it by the incisive strokes of a stonemason so skilled as to be capable of making stone itself speak even of itself. As, in drama, what is said of the events, characters, and pathos depicted by a scene is said on the scene itself, in the very depiction, the seemingly dead words of the poet being cast into the living speech of the characters on stage. Even if in both cases a certain intervention is required, completing while also disrupting the circle of self-representation: in lithography, the skillful practice of the stonemason; in drama, the pretense of the actor.

Imagine, then, a theatre of stone.

Imagine being there among the spectators, eyes trained on the spectacle, listening to what will have been, on the other hand, mostly *just written* of stone, except for the few images that supplement the text, that present, from without, something of what is said, the merest trace of the spectacle itself. But it is not only of stone

Stone bell. Dvaravati. 7th–9th centuries.
From Pra Pathom Chedi, Nakhon, Pathom.
In National Museum, Bangkok, Thailand.

that something is to be said, but also of theatre, of art. Not, however, in the way that aesthetics would have one write of art, referring the work of art to the affective sensibility of the one who experiences the work; or, by reversing this feminine aesthetics, by changing its sex, referring everything to the productive capacities of the artist himself. Rather, with an orientation to what both Hegel and Heidegger venture to call the *truth* of art. It will be a question of the power of that truth: first, as it is called most profoundly into question at that point where Hegel conjoins to a certain consummation of metaphysics a recollection of the entire history of art; then, at the point where, responding to the limit by which Hegel determined art as essentially past, Heidegger ventures to rethink art in the depths of its truth.

This is, then, what is to be said: art in its truth, in the power of its truth. One could call it, perhaps in every case, *shining truth.*

Such is the first name of the beautiful. Plato's word is τὸ ἐκφανέστατον:[1] the most radiant, that which most shines forth

1. Plato, *Phaedrus* 250d-e.

amidst the visible, in the singular things that come to be and pass away. Beauty would name the preeminent way in which being as such shines forth in and through visible things. It is also said to be a shining capable of drawing the soul upward, of restoring the wings with which love would soar beyond those things, upward toward the heavenly element to which the soul would be akin, upward away from all that would weigh it down, upward away from the earth.

Hegel repeats the Platonic determination, bringing it into play throughout his extensive analyses of the forms and particular modes of art as well as in his interpretations of various works of art as exemplifying those forms and modes. The beautiful he explicitly defines as "the sensible *shining* of the idea [*das sinnliche* Scheinen *der Idee*]."[2] It is not as if there are also other kinds of shining: *shining* names the way in which something beautiful offers itself to sense, in distinction from objects that are perceived, desired, or comprehended through theoretical intelligence. For Hegel art is the sensible presentation (*sinnliche Darstellung*) of truth—that is, the presentation of truth in and through the shining of the work to sense.

One can say almost the same of Heidegger. As does one of those unnamed voices in Derrida's polylogue on *The Origin of the Work of Art*: necessary though it be, Heidegger's questioning repeats the traditional philosophy of art.[3] So then, a necessary repetition, which is to say one that does not simply repeat or that, in repeating, produces at the same time a certain divergence. In his own voice Heidegger marks the repetition, or rather marks it in a kind of repetition, in an echo that sounds after *The Origin of the Work of Art*, in the Afterword: "When truth sets itself into the work, it appears. The appearing [*Erscheinen*, says Heidegger] is . . . beauty."[4] In the words of Heidegger's letter to Krämer-Badoni: beauty is to be

2. G. W. F. Hegel, *Ästhetik*, ed. Friedrich Bassenge (Berlin: Verlag das europäische Buch, 1985), 1:117. Hereafter: *A*, followed by volume and page numbers.

3. Jacques Derrida, *La vérité en peinture* (Paris: Flammarion, 1978), 299.

4. Martin Heidegger, "Der Ursprung des Kunstwerkes," in *Holzwege*, vol. 5 of *Gesamtausgabe* (Frankfurt a.M.: Vittorio Klostermann, 1977), 69. Hereafter *UK*, followed by page number.

thought "as a way of shining."[5] Art is, then, to be thought from the artwork: the work gives place to truth, provides the place where truth can appear, can shine. It is imperative to recognize that such discourse has never been a matter of uniform generality. For the conjunction, shining truth, designates nothing less than an interruption of the very order of generality, a peculiar suspension of the difference that otherwise separates the eidetic from the singular, a *peculiar* suspension in that its very force requires that the difference remain, in the moment of suspension, also intact. This interruption is one that philosophy has acknowledged, even welcomed, yet also found difficult to accept, even repressed.

Here, then, it will be a matter of interrupting the generality of the discourse, of inscribing also a series of discourses that, in different ways, bear irreducibly on the particular, even the singular, spacing the discourse in such a way that it could never simply be assimilated to the purely eidetic. I shall offer, then, some discourses on the shining of stone—that is, on the shining of truth in stone, in the shining of stone. Repeatedly, these discourses will revert to what, in an essentially general discourse, would seem to be merely examples, for instance, to a particular art in which stone is made to shine in a distinctive way, even to single works of art in which a singular (and yet also not simply singular) shining of truth takes place. The discourses will thus be limited, in large part, to examples, limited by examples, in this reversion following the very limitation that truth undergoes in coming to shine.

It will be a matter, then, of attempting to say things in a way that lets the shining of their stone be manifest, that lets be manifest what is gathered in and into that shining. Regardless of whether the thing spoken of be an artwork of stone or an implement of stone or stone yet unshaped, perhaps unshapeable, by human hands (one will not be long coming across examples that violate and confound these simple disjunctions), what will be required, above all, is reticence, the reticence that refuses the well-prepared appropriation of shining to readily disposable concepts. For such appropriation

5. "Ein Brief Martin Heideggers an Rudolf Krämer-Badoni über die Kunst," *Phänomenologische Forschungen* 18 (1986), 178. The letter is dated 25 April 1960.

would have the effect of forestalling the very interruption announced by *shining truth*, of simply suspending the suspension and reestablishing a uniform order of generality, repeating the philosophical repression of shining. To say nothing of the uncritical character of such appropriation.

Within the clearing of such reticence it will be possible, perhaps necessary, to call upon certain discourses of philosophy, or rather, discourses at the limit—at different limits—of philosophy, as well as upon an instance of poetic discourse, indeed one belonging to the theatre. In the reticent appeal it will be a matter both of forestalling the appropriation of shining and of seeking out a few fragments of language capable of bespeaking it.

What is needed is to break the silence of wonder without dissimulating the very shining that will have evoked it.

Especially if one would say directly the shining of stone, forgoing or at least deferring the appeal to other, liminal discourses, it will be necessary to destabilize in one way or another those forms of discourse, both semantic and syntactic, that would otherwise have the effect of reinscribing what is said of stone back into the framework constituted by such classical categories as quantity, quality, and relation—to say nothing of that category of categories, namely, substance, to which a discourse on stone would tend, almost as if by nature. Not that one would simply forgo addressing, for example, what would be called the permanence or the hardness of stone. But they will have to be addressed differently: not as though the hardness of stone were a mere property belonging to something (both Hegel and Heidegger have, in very different ways, effectively undermined this schema, demonstrating its abstractness); rather, for instance, as it is integral to the capacity of stone to bear weight, not unlike the earth itself, the final bearer of all. Stone is of the earth, and its hardness, for example, will need to be said in terms of that belongingness. As will also its permanence, which makes it such a suitable marker for the sites where those who are dead and gone are buried. But even in addressing it in these ways, one will still need to exercise constant vigilance so as to divert what is said away from reenclosure in the categorial framework, stalling that force of appropriation that one will perhaps never be able simply to have forestalled once and for all. Exercising vigilance, then. And reservation.

But what of stone today?—venturing for a moment to juxtapose (harshly, no doubt) the fleeting now of the human world and the persistent antiquity of stone. What sense does it now display? An impoverished sense, no doubt, now that stone has lost its ancient privilege. Stone no longer counts as it once did, as it always did until recently, until the onset of what is called the epoch of technology. More and more of what would once have had to be manifestly of stone can now be produced—with unquestionable advantages—by technological means, so that, for instance, the great buildings of today are not of stone but of steel, glass, and concrete. In them, today, something different comes to the light of day, a shining that is not that of stone.

In writing of stone one would, then, seek to supplement the sense of stone, without perhaps being able to know, in advance of such writing, that there is need of recovering its sense or even that there is a deeper or enhanced sense to be recovered. And yet, writing of stone adds nothing to its sense; mere writing (as we say) cannot simply recreate a sense that today has diminished. On the contrary, writing can supplement the sense of stone only to the extent of confirming that here and there—in the midst of the ever-accelerating transformation to which the earth is today submitted, or perhaps aside somewhat from that transformation, in a region that still resists it—stone still shines forth with a brilliance of sense that escapes those forces that would enclose and diminish it. In writing of stone one will be in search of a language that will expose that brilliance of sense, in the double sense of revealing it by opening it to language, seeking (without hope of success, without knowing even how success could be measured) to transpose that very brilliance into words, to reproduce in language the brilliance of the sense of stone.

Seeking, then, to tell—if not without also stammering, perhaps necessarily—of how stone still shines today. If only in a few remote instances or places.

As in the sight of an ancient boundary stone of the Sukho Thai style dating from the fifteenth century. Today the ancient practice of using such stones to mark boundaries or limits has almost disappeared. What such stones once marked can now be marked in abstraction from the places themselves by the use of maps, coordi-

Boundary stone. Sukho Thai style. 15th century.
From Wat Pwra Singha. Kamphaeng Phet.
In Kamphaeng Phet National Museum, Thailand.

nates, etc.; and in those cases where it remains necessary to mark
the places themselves, this can be done with much greater efficiency
by the use of fabricated markers or signs. And yet, in the face of
such a stone, even if one sees it only in a museum, one senses that
something different has been in play, an appropriateness to that
marking of the earth's surface by which places are delimited and
ways or routes staked out. One *senses* an appropriateness, without
knowing that or what it is. One senses it with a certain reticence,
with a sense that to intrude too readily with the language and con-

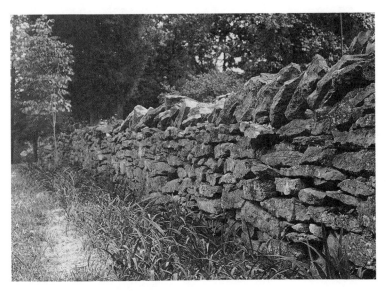

Stone fence. Nashville, Tennessee.

cepts at one's immediate disposal would serve only to dissipate what is manifest in the shining of the stone. In the face of the ancient boundary stone one senses its way of belonging to that which it marks and bounds, a double relation to the earth that is possible only because the stone has been detached, has been shaped by human hands, has been stamped with the look of a certain human world, in this case an ancient and remote world, hardly recognizable except in a certain style displayed by the shape of the stone and the figures carved on it. One senses and would like to say this redoubled belonging, even if one's sense of the stone carries with it a certain oblique awareness of how effectively the stone's belongingness will elude one's every effort to say it. One stammers perhaps. Or falls silent.

Or perhaps one turns to something less remote, less alien, for example, the stone fences that were once used to mark the boundaries of fields and that one still sees in England and in certain parts of the United States. Here and there they even serve still to parti-

tion and to mark the partitioning of the land, even if in such cases one cannot but sense that they belong properly to a world that has today withdrawn. Still, the look of that world shines forth in the array of neatly stacked stones; it is a world that is still largely accessible, and one could, using the available vehicles of mediation, reconstruct theoretically the insertion of the stone fences in that world. But their way of belonging to that which they partition and mark, the double relation to the earth, remains more something sensed than something immediately sayable.

Stone can mark not only a boundary but also a former presence, as in those self-images that nature prints in stone. In fossils one senses a kind of natural history, unassimilable to what philosophy delimits as history and sets in opposition to nature. In this instance not only is the classical opposition violated, confounded, but also what is here imaged in stone is sensed as exceeding the present image, as withdrawn into a past utterly remote from, as we say, all human experience. A reminder perhaps that might extend what Heidegger says of the irreducibility of art to experience: that experience is perhaps the element in which art dies, in which it suffers a slow death dragging on for centuries (*UK* 67). One could say much the same of nature, or rather, of that which, even if one still has no other name for it, opens to us in a way that is not said in what remains of *nature*. In the fossil one finds perhaps a reminder that what can be manifest in what is called nature, addressing our eyes, ears, and legs in a language largely untranslatable into speech, drawing us mutely to its forests, rivers, and mountains, is irreducible to a content experienceable in the living present.

Perhaps, too, it is in some instances different from what could be called beautiful. Truth shining still more interruptively.

For instance, a glacier-covered mountain peak such as that of Mont Blanc. In its presence one senses, above all, excess. Excess— not as an experienced content, to be expressed then in general in the word, but rather as an exceeding of every content circumscribable in and by experience, of every presence determined by the living present of experience. The word *sublime* springs to one's lips as one recalls Kant's account of how the sublime is apprehended, not as a positive determination, but as an unlimitedness, an exceeding, in

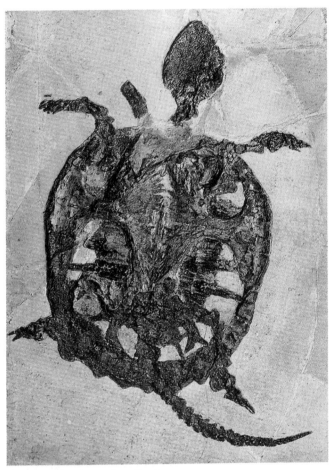

Fossil of pond tortoise. Oeningen.
Teylers Museum, Haarlem, Netherlands.

the order of magnitude or power. Kant insists that one finds sublime things only in raw nature, not in things of nature determined by definite purposes and not in products of art; strictly speaking, there are, for example, no sublime buildings no matter how magnific, despite the descriptions that Kant himself gives of the pyramids and of St. Peter's, descriptions meant to illustrate aspects of the sublime.

One finds the sublime only in nature "in its chaos or in its wildest and most irregular disorder and desolation," as in the vision of "shapeless masses of mountains piled in wild disorder upon one another with their pyramids of ice,"[6] as in "the sight of a mountain whose snow-covered peak rises above the clouds."[7] Or rather, one *would* find sublime things in such sights *if* there were, strictly speaking, genuinely sublime things and not merely things capable of presenting a sublimity that is never itself to be found among things but only within man himself. Thus, despite the very remarkable descriptions in which Kant tells of how one's imagination is drawn to its limit when one attempts to apprehend some sublime thing in nature and of how in reaching that limit one experiences the excess of nature, its infinity, as Kant calls it[8]—despite these magnificent descriptions Kant insists, in the end, that "the sublime is to be sought not in the things of nature but only in our ideas," that "true sublimity must be sought only in the mind of the one who judges," as a "disposition of the spirit [*Geistesstimmung*]."[9] Thus, the sublimity of nature is withdrawn into the subject, submitted to and transposed into the very element of experience that one might instead—and in the wake of Kant's own descriptions—have taken it to exceed most decisively. In the end, nature's exceeding of man's imaginative capacity to apprehend it is taken as no more than a sensible schema for reason's exceeding of sensibility, and the sight of the sublime is made to serve only to reveal the difference between the sensible and the supersensible in man. The excessive magnitude or power of the sublime thing of nature is no more than a sensible

6. I. Kant, *Kritik der Urteilskraft*, in *Kants Gesammelte Schriften*, ed. Preussische Akademie der Wissenschaft (Berlin, 1902–), §§23, 26. I have discussed at length Kant's theory of the sublime in *Spacings—of Reason and Imagination. In Texts of Kant, Fichte, Hegel* (Chicago: University of Chicago Press, 1987), chap. 4.

7. Kant, *Beobachtungen über das Gefühl des Schönen und Erhabenen*, in *Kants Gesammelte Schriften*, 2:208.

8. "Nature is therefore sublime in those of its appearances whose intuition brings with it the idea of its infinity. This last can occur in no other way than through the inadequacy of the greatest striving of our imagination to estimate the magnitude of an object" (*Kritik der Urteilskraft*, §26).

9. Ibid., §§25–26.

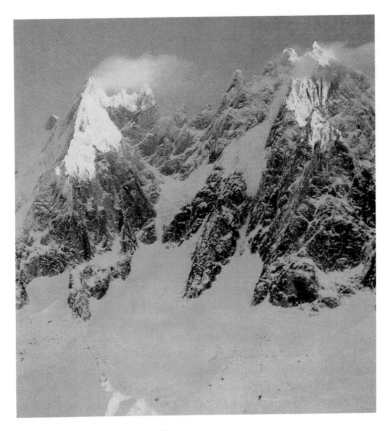

Mont Blanc. Haute Savoie, France.

transcription of the elevation of the supersensible and of the eleva-
tion offered to man by the supersensible within him. In the end,
the sublime has the effect of confirming the metaphysical within
man and of enclosing man within the metaphysical. Even if there
remain openings in Kant's text that are not easily assimilated to the
reduction of sublime nature. As in the course of describing what
he calls *Erschütterung*, the trembling, the tremor that runs through
us in the face of a sublime thing of nature: "That which is excessive
for the imagination (up to which it is impelled in the apprehension

of intuition) is, as it were, an abyss [*Abgrund*], in which it fears to lose itself."[10]

Merely activating the language of the sublime will not, then, suffice for saying the excessive brilliance of the mountain peak, however much one may want—in view of the openings in Kant's own text—to reserve the word for a reinscription that might eventually be prepared beyond the reach of the metaphysical reduction of the sublime. In the interim it will be necessary to dislocate the primary determinations that govern the Kantian analysis of (non)sublime nature and that remain decisively, if often surreptitiously, in effect in virtually every subsequent adaptation or transformation of that Kantian analysis.

In the presence of the mountain peak one senses, above all, excess; it is excess that is manifest as the very sense present in the presence of the mountain peak. Or rather, one might begin preparing a suitable discourse by tracing these arcs: a sense of excess, excess as sense, excess of sense, in excess of sense. Etymologically, *sense* is linked to the Latin *sensus, sentire,* which translate the Greek αἴσθησις and αἰσθάνομαι; in Greek philosophy from Plato on, αἴσθησις is linked to, as we say, the senses and so is opposed to νόησις, apprehension accomplished not through the senses but through thought, through the power of *intellectus,* of νοῦς. And yet, what is remarkable is the way in which *sense* erodes this opposition, the most fundamental of the oppositions that philosophy would establish, one that other fundamental oppositions more or less just redouble; it is the opposition that first establishes the very concept of ground, of fundament, of fundamental, as well as preparing even the concept of concept, the sense of concept. In itself the word *sense* houses the most gigantic ambivalence, indifferently coupling the difference between what is called the sensible, things of sense apprehended perceptually, *and* signification, meaning, a signified or intended sense. One will speak of course of the two senses of sense, not without marking in the very phrase the abysmal character of the differentiation: to differentiate between the two

10. Ibid., §27.

senses of sense presupposes the very differentiation that it would effect. In dealing with sense one will never have gotten to the bottom of things. The ambivalence of *sense* is further compounded by its indifference with respect to the difference between apprehending and apprehended (to sense something, to have a sense for it, is to apprehend its sense); in this way the word also serves to erode the opposition between experiencing subject and experienced object, the opposition, the rigid distinction, required by the Kantian reduction of sublime nature, required in order that the imagination be saved from losing itself in the sublime abyss. In the word *sense* these oppositions are made to tremble, its two senses sliding together, as the redoubling within each (between experience and experienced) is equally eroded. Not to mention still another sense of sense, preserved in the French *sens* and obtrusively manifest in the upward thrust of the peak.

To sense the mountain peak in its excess is neither simply to perceive it nor simply to refer to it by way of a meaning intention (that is, by the detour through a concept). It is—in a sense—both perception and conception, both intuition and thought. But it is also—in a sense—neither.

It is, above all, neither. It is a sensing in which even the gigantic space within the word, that of its abysmal ambivalence, is exceeded. No blending will suffice to capture it, no combination of perception, in its classical determination as intuition, *Anschauung*, αἴσθησις, *and* conception, regarded either as a mere meaning intention or as an act in which the perceived would be brought, in some manner, under the concept (in the most extreme instance, under the perfectly singular concept that the name of the mountain could be taken to signify). The sensing of the mountain peak and the mountain peak as sensed exceed these classical modes of comportment and refuse to be enclosed within the orbit they define. It is a sensing that is not to be domesticated by an experience circulating between percept and concept, thing and meaning. An exorbitant sensing. A sense of the wild. Not only raw nature, as Kant would have it, but wild nature. An exorbitant sensing of a wildness in nature.

A more ancient saying would be fitting here. First of all, a saying

of saying, one that has been heard echoing in the words of Heraclitus: saying as responsiveness to a gathering that will always have preceded it and that, in evoking speech, will always remain aloof, withdrawing under cover so as to forestall any definitive appropriation by and to the living present of speech, the moment in which speech would itself gather what is said into presence. The gathering to which speech would be thus submitted is a wild one. In the most exceptional case, that in which the gathering would itself be said, speech would come to be added to the gathering, bringing it to a certain presence in the word, yet not without provoking—and in the highest instance also saying—a recoil by which the wild one evades every trap set to snare it, to leave it exposed to the light of day, to prevent its nocturnal retreat to its place of hiding. As such, speech will never fail to be confronted and threatened by the truth that Heraclitus said in these words: φύσις κρύπτεσθαι φιλεῖ.[11] Roughly, without trying to mark the necessary reservations, one may translate: nature loves to hide itself.

What, then, of the gathering sensed in the presence of the mountain peak? How is it to be said in its wildness? How is it to be traced, tracked, on its way back toward its shelter? One way would be to begin speaking again—though differently—of what the ancients called ῥιζώματα or στοιχεῖα. The first of these, which means, first of all, *roots*, is the word by which Empedocles speaks of what are called fire, water, earth, and air. These four are the roots that provide sustenance for all things, that enable the things of nature to emerge, to grow, to come to light, to unfold into the open that the roots delimit. Thus are the roots taken as what enables nature itself (φύσις). Thus also does Empedocles say that all things were *from these* (ἐκ τούτων), from the roots.[12] In Plato the word is replaced by στοιχεῖα, which for a long time was restricted to the elements of speech, the simple sounds from which speech was composed; only in the *Theaetetus* (201e) does the word get extended to the elements of things, though still not quite definitively.[13] What is especially de-

11. Heraclitus, Fragment 123 (Diels-Kranz).
12. Empedocles, Fragment 17 (Diels-Kranz).
13. Note the reservation expressed in the *Timaeus* 48c.

cisive in governing the word in Plato and Aristotle is its differentiation from ἀρχή: the elements do not constitute the origin of things, the beginning, which both Plato and Aristotle determine, instead, by way of the differentiation between so-called intelligible and sensible, that is, by way of the gigantic ambivalence in *sense*, to be fixed through the γιγαντομαχία περὶ τῆς οὐσίας. The result is that discourse on the elements harbors a certain resistance to the metaphysical opposition, a resistance that, even if it tends to be largely domesticated from Aristotle on, is manifest in the discussion of the elements found near the center of the *Timaeus*, manifest especially in that strange affiliation that air, earth, fire, and water (as they are called but cannot, according to the *Timaeus*, be properly called) have with that third kind added to the twofold of intelligible and sensible and called χώρα.[14]

It is this resistance, along with the link to the Empedoclean roots, that would be put into play in beginning to speak again of the elements. Even if now one cannot but speak of them differently.

In the presence of the mountain peak one senses a gathering of the elements. The mountain is earth itself, thrusting upward toward the sky, upward through mist and clouds (ἀήρ), upward into that pure and shining upper air that the ancients called αἰθήρ and frequently regarded, in its brilliance, as the region of the fire of heaven. Up there, above the clouds drifting lightly across its lower slopes, up there under the clear sky the mountain peak is covered with snow and ice, the glacier merging with the peak itself, becoming the peak in its uppermost reach toward the sky. It is as if it were stone turned white, collecting the light and transparency of the upper region so as to image them in earth, in a white that, as one approaches it, proves to be also opaque, almost dark, earthy. Up there in the aethereal region the icy peak is exposed to the fire of heaven, whitened stone shining brilliantly in the intense sunlight, earth extended and exposed to the sky. In the mountain peak, fire and ice are gathered in (as we say) their elemental opposition. And yet, the mountain is stone, as one can see around the edges of the glacier, on the lower slopes where the hot summer sun has melted away the snow

14. See *Timaeus* 48e–50c.

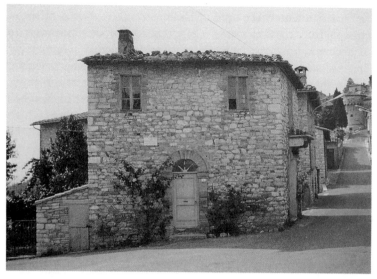

Old stone house. Corciano, Italy.

and ice. Letting the elements be gathered around it, the mountain peak *is* nonetheless itself one of the elements. As stone, it is of the earth.

A thunderstorm changes the appearance, its lightning bolts steering the elements along another way, clouds and heavy rain making the mountain peak recede into invisibility. There is perhaps no other occasion when one has such an intense sense of shelter. In such mountainous terrain one would in former times almost certainly have taken refuge in a house built of stone, of stone quarried from the mountains and formed so as to serve man's need of shelter. In the hardness of its stone, the capacity of the house to shelter and protect is manifest, is testified. In the very shining of the stone, one senses what a touch of the hand will more directly attest. If it is an old house, one will sense also in its worn stones the traces of an obscure lineage, a certain human history inscribed—without having been, in any active or intentional way, inscribed—on the stone. Nature and history—the opposition again violated, confounded.

In a thunderstorm the elements rage above us and around us, and

one senses intensely the need of shelter. But there is need of shelter not only from these elements. There is need, too, of a more obscure sheltering in relation to what is (as we say) elemental in human life. There is need, for example, to shelter solitude (*Einsamkeit*), whether within the enclosure of a dwelling or in the open air of the mountain slopes. There is need to shelter a child within the home where there is protection from the direct impact of what is alien, a place in which to grow into the light, as the child once grew, sheltered, in preparation for birth. To say nothing of the need to shelter the dead, not only to inter them, but also to shelter them from the oblivion that time itself brings. As when, at the site of a grave, in memory of the one dead and gone, those who survive place a stone.

2

VORBEI

THE OLD JEWISH cemetery in Prague is a jumble of gray and brownish stones crowded into a small, walled-in area in what was once the Prague ghetto. The stones are packed in so densely that one knows, even before reading of it, that several thousand are buried here. Even the briefest of histories intensifies the initial impression. Established in the mid-fifteenth century, the cemetery was, it seems, crowded almost from the beginning. Even though additional land was bought, it appears that from an early date there was insufficient space to allow the dead to be buried next to one another. Since religious precept forbade disturbing the graves, it became necessary to cover existing graves repeatedly with new earth, the dead thus being buried in numerous layers on top of one another. In some parts of the cemetery there are as many as twelve layers. Each time that new earth was brought in to cover existing graves and make possible new ones, the old gravestones were lifted to the new level. Since all the gravestones were thus kept on the surface, their number increased until finally they were packed in with the density that one observes today.[1]

Now nearly all the stones are leaning, protruding at various inclinations from the black earth, a spectacle of utter disarray. Some are leaning at such a sharp angle that they seem ready to topple over. One has the impression that their thrust, though persistent, has grown feeble with the passing of time, that even stone, thrusting upward into the open, is drawn back toward the earth, toward the

1. See Wilfried Brosche, "Das Ghetto von Prag," in *Die Juden in den böhmischen Ländern* (Munich/Vienna: R. Oldenbourg, 1983), 87–122, esp. 106. Also Jindrich Lion, *The Prague Ghetto* (London: Spring Books, n.d.), esp. 25–30.

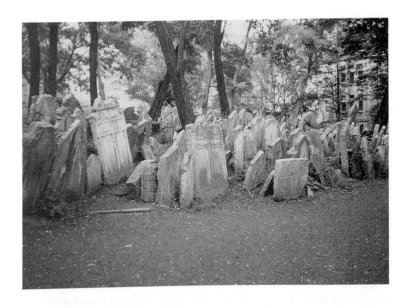

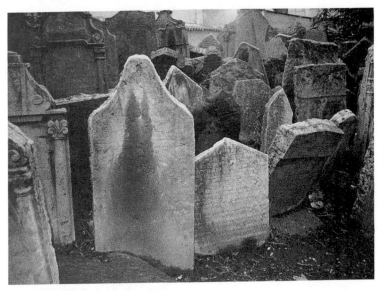

The old Jewish cemetery. Prague.

silence of those who, though dead and gone, would be memorialized by the stones.

At first one cannot but meet this strange sight with silence. It is not so much that words are lacking, but rather that one senses the need to hold them back, not to let them intrude, uninvited, upon the silent spectacle, like alien ghosts trampling over the graves of an unknown people. It is as if the very strangeness of the sight, the alienness of the silent spectacle, would be violated if brought back prematurely to the familiarity of one's native tongue. And so, at first, one just looks at the disarray of tombstones, matching it with a stony gaze, silence on both sides.

Or perhaps, for a moment, one grants phantasy its play. One pictures the mountain, cloud-covered for six days, the Lord appearing on the seventh day, like a devouring fire on the top of the mountain, calling Moses up to the mountaintop that he might receive the stone tablets on which the law and commandments are inscribed. Through traditional depictions these tablets of the law have come to assume a certain appearance, an appearance easily called up, as by those stones in the old Jewish cemetery that share to an extent that appearance.

But on many of the gravestones the inscriptions are either completely effaced or so nearly gone as to be no longer legible. Still, there are some on which indeed names and epitaphs can be read and figures and decorative patterns discerned. On a few of the stones the inscriptions are sufficient to allow the individual to be identified, most notably, in some cases where there is also independent information about the individual. As in the case of David Gans, the eminent scientist, a friend of Tycho Brahe and Johannes Kepler: on the gravestone, along with the star of David, there is the figure of a goose. Likewise with the grave of Rabbi Loew, renowned as the creator of the Golem: his tomb, in Renaissance style with some Baroque features, is not only one of the best preserved but also was, even into this century, a site for pilgrimages by orthodox Jews who, troubled or needy, sought to tap the magical power of the great rabbi. On a number of the gravestones the sculpted figures serve to indicate the profession of the deceased, scissors, for example, designating a tailor, a mortar and pestle indicating a pharmacist, a violin

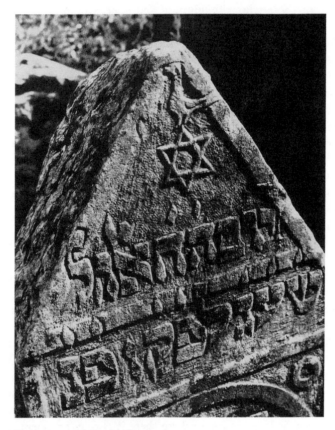

Gravestone of David Gans.
Old Jewish cemetery. Prague.

identifying a musician. The figure of a little girl carved on one of
the stones indicates that the grave is that of a child. On a number
of others the figures serve to indicate names, as in the case of David
Gans, though mostly just family names, so that, unless there is suf-
ficient independent information, one loses sight of the individual
deceased and learns from the gravestone only that someone of a cer-
tain family is buried there. The figure of a fish marks the grave of
someone named Fisch or Karpeles, the figure of a leaping ram indi-

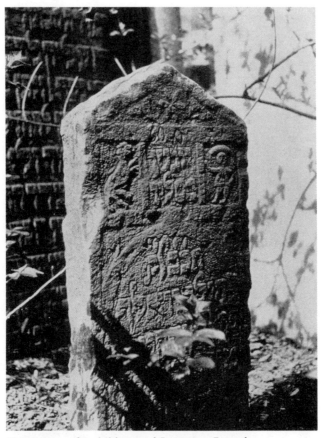

Gravestone of a child named Lamm or Lampl.
Old Jewish cemetery. Prague.

cates that the deceased was named Lamm or Lampl, and the figure
of a stag identifies the grave of someone named Hirsch, Hirschl, or
some variation thereof.[2]

By way of the inscriptions and figures the stones thus offer a
visible trace of the memorialized one, setting in the light of day, in

2. See Lion, *The Old Prague Jewish Cemetery* (Artia, 1960). Also, Lion, *The
Prague Ghetto*, esp. 28.

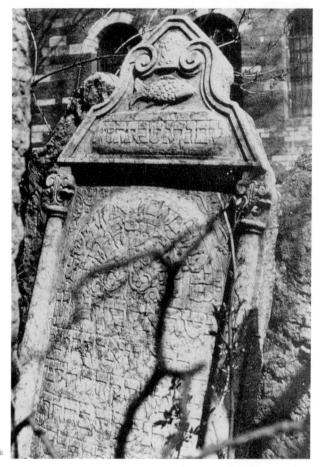

Gravestone of someone named Fisch or Karpeles.
Old Jewish cemetery. Prague.

stone, a mark or group of marks indicative of the deceased. In a few cases the person's individuality is marked, but in a number of others the marking is more generic, indicating family or profession. Indeed, on a great many of the stones one can see no more than that such marks may once have been inscribed, so that the dead whom

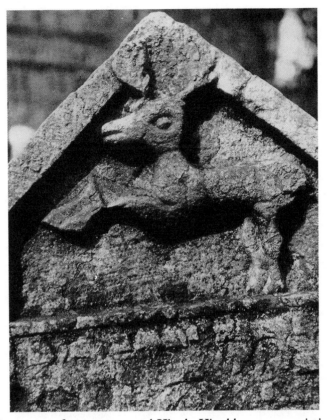

Gravestone of someone named Hirsch, Hirschl, or some variation thereof.
Old Jewish cemetery. Prague.

they still memorialize come to light only anonymously, as more general individuals, former inhabitants of the Prague ghetto.

Along the vertical edges of several of the stones there are sculpted columns or half-columns with elaborate capitals, and one is struck by the sharp contrast between this appearance of architectural-like support and the actual state of the cemetery. The stones show the wear of time, a certain aging that is no more than a process of being worn away, an aging that one would need by all means

to differentiate from that of living things, especially from the human process of aging, from the way in which, stretched knowingly between birth and death, human beings bear and show their individual temporality in virtually every look and gesture. Stone, on the other hand, ages by being worn away by water, air, ice, and sun; it is worn away by the other elements in a time different from that of human aging. One could call it an elemental time. Or a time of the earth.

Precisely because the gravestones show the wear of time, they can evoke an awareness of the peculiar temporality of stone: stone is ancient, not only in the sense that it withstands the wear of time better than other natural things, but also in the sense that its antiquity is of the order of the always already. Stone comes from a past that has never been present, a past unassimilable to the order of time in which things come and go in the human world; and that nonbelonging of stone is precisely what qualifies it to mark and hence memorialize such comings and goings, births and deaths. As if stone were a sensible image of timelessness, the ideal material on which to inscribe marks capable of visibly memorializing into an indefinite future one who is dead and gone.

By being walled in, the cemetery forms a kind of ghetto within the ghetto—or rather, within what was once the ghetto, one so well-known that Hitler chose it as the site where he planned to build a museum to an extinct race. Now, of course, there is no longer a ghetto in Prague. Not that the place has been destroyed, this place once closed off as the place of the other, this place where the other remained other within, yet separated from, the otherwise selfsame city. Now it is preserved and opened up to all, made a scene for all to visit, generating return no doubt on the capital used to open and preserve it. Now it has at least begun to be assimilated to a general economy that tolerates no closing off, an economy that assimilates all, a politics that declares as its imperative: Let there be no more ghettos! Let there be no more walls!—except perhaps around old cemeteries with their worn, worthless old stones. Let these sites of the absolutely unassimilable, of death and the dead, remain walled in—the better to be assimilated to the economy.

Yet, as, after the holocaust, a politics of the ghetto has become absolutely unthinkable, the need has become all the more urgent to recognize that assimilation too can be violent, and not only when driven by the forces of an unrestrained capitalism, not only when facilitated by the *Gleichschaltung* of which technology is not only capable but from which it is also inseparable. One needs to recognize too that assimilation becomes more violent the more the other resists assimilation, the more decisively other the other is or becomes. The question is whether we today can think beyond this all-too-symmetrical opposition between the ghetto that would enforce otherness and the assimilation that would enforce sameness.

It is a question not only of another politics or political economy but of a different logic, a logic of the political, a logic that would no longer regard difference merely as limiting an otherwise selfsame political or cultural unit, preventing that unit from being fully unitary, genuinely itself, dividing it from itself, hence a difference to be minimized or at least isolated and enclosed—that is, either assimilated or ghettoized. What is needed is, first of all, a logic capable of thinking difference as belonging to political or cultural identity: difference, coming to divide the unit from itself, would be the very condition of the possibility of affirming sameness with itself, self-identity as the overcoming of separation from self. But such a thought of difference, already essentially realized in German Idealism, is only one moment of the double thought, the double logic, that could perhaps begin to reorient a field exhausted by the collapse of what was to have been the concrete realization of the dialectical work of difference, even if finally it came down to just another totalitarianism. But it would be the worst sort of error if, in the face of this collapse, we now retreated into the old thinking that simply opposes identity and difference, if we now failed to recognize the need to think difference even beyond the point where it would mediate self-identity. What is needed, instead, is the following: not only to think difference as belonging to political or cultural identity, but also—as the other moment of a double logic—to think such identity as belonging to difference. This other moment is no mere reversal, not even a complementary opposite, of the dialectical mo-

ment. Indeed, one could call it a moment only insofar as one began to twist such language away from the dialectical logic that would tend otherwise to control it.

How is one to think identity as belonging to difference? What kind of logic would be required? Could one even continue—without a certain interruption—to speak of kinds and to frame one's questions regarding this double logic as if it were, without question, a matter of kinds, of typology? And, within such a logic, could one stabilize the slippage of the very language of same and other, of identity and difference, stabilize it sufficiently to allow a coherent discourse, assuming (as one perhaps could not, in the end) that the criteria for coherence in discourse would remain relatively determinate even in such doubling of logic?

At the very least one could say that in such a logic of the political the self-identity of a political or cultural unit would be regarded as constituted in its being different from itself. A contradiction of course, according to the logic that was determined by Greek metaphysics: within that logic contradiction signals a halt, a place where one can go no further, a stop from which one will need to back up, as out of a dead-end street, and start off in another direction. But if, instead, one persisted with the contradiction, as a dialectical logic would prescribe, one could avoid the reduction of difference only by reconfiguring self-identity, construing it, not as identification with itself, not as the assertion of an identity overreaching the differential separation from itself, but rather as what is proper to it as such, what constitutes its ownness, which, as in Heidegger's analysis of death, can endure the persistent interruption brought by what is irreducibly other, by a difference that one will then want to cultivate in the interest of one's own country, welcoming the foreigner, as Derrida says, not only to integrate him but to recognize and accept his alterity.[3] A double hospitality.

A logic of the political will also have to address two phenomena, two expansions or generalizings, now discernibly in play in the political actuality; or rather, such a logic will have to endure these phe-

3. Jacques Derrida, *L'Autre Cap* (Paris: Les Éditions de Minuit, 1991), 75.

nomena, perhaps even finding in their configurations the very fig-
ures that could provide its determination and structure. The first of
these phenomena is produced by the dynamics released through the
unrestrained spread of Western culture (its politics, its economy, its
technology, its telecommunications, etc.) to the entire world. As a
result, all the structures, questions, and antinomies that pertain to
the relation of a Western city to the space of the other within it are
generalized and—though not without certain critical limits—dupli-
cated in the relation of the West to the non-Western world. As West-
ern culture has to some extent penetrated virtually everywhere with
its imposing technology and economy, there has also been ever more
intense resistance to assimilation, resistance from the depths of non-
Western cultures (if one can still use such figures), resistance that
has proven capable of intensifying even into open warfare.

The other phenomenon is a certain disruption of the political and
cultural unit as such, the emergence of structures that cut across
and render ineffective such units as the city and the nation, that is,
the units that have been thought beginning with the πόλις, that
have been thought from the πόλις, which thus informs fundamen-
tally—and of course even lends its name to—what is called political
thought. It appears that the day will soon come—perhaps has al-
ready arrived—when it will be necessary to think what has been
called the political without thinking it from the πόλις, without
thinking it as a set of more or less selfsame units limited from within
and especially from without by what is other.

One will need, then, to reopen at every level the question of same
and other. Even though—indeed, because—it is an ancient ques-
tion. Ancient, almost like stone.

But I have wandered. Let us return to the old cemetery and linger
just a bit longer within its walls, closing out the sounds of the city,
listening to the silence within. Here one hears with one's eyes, hears
the silent appeal of the stones for a kind of remembrance. What
kind? Not a remembrance in which one would call up an image of
someone once seen, actually or in an image, or even once read of in
a narrative about the Prague ghetto, fictional or otherwise. It is in
no sense a calling from within oneself but rather a call coming from

the stones themselves as their silent presence begins to announce
that someone whose earthy remains lie buried below has once lived
and died, someone whose name or other identifying mark may or
may not still be legible on the stone, in any case a stranger whose
absence is utterly sealed. And yet, without violating that seal, the
stones bring the dead back; they summon the dead in the very an-
nouncing of the seal that forever deprives the dead of presence.
Thrusting upward into the light of day, reflecting even some rays
of sunlight, the shining stones produce a simulacrum of rebirth, of
the rebirth of those long dead, of those who, in being reborn, re-
main nonetheless dead, absent, silent.

In the cemetery there is a simple stone marking the grave of a
butcher named David Kacev, who died in 1656. On the stone there
is an inscription that tells of the butcher's good deeds: that he kept
and supported orphans, that every Friday he donated a large quan-
tity of meat to the poor and homeless, that he donated a new copper
candlestick to the school, that he was a generous friend to the
learned rabbis. The inscription concludes: "Therefore may his soul
remain among the living."[4]

Eventually one will break the silence, though reluctantly and only
after having lingered for some time within the walls. For if any sight
could make one experience the need to be addressed before speak-
ing, the need to speak only responsively, it is the sight of the old
cemetery. When the moment finally came, I would venture only a
single word, one not quite native, forgoing still the assimilation of
the sight to the familiarity of the mother tongue. The word uttered
finally in response to the sight, the first word evoked by the disarray
of gravestones closed off within the great Baroque city where, even
still, as a foreigner one most often speaks German—the word is:
vorbei. First of all, in the common sense: it's past, it's over and done
with. As one says of winter when it finally begins to recede: it's over,
it's gone. But also in the sense that Heidegger released in the word,
an inherently unstable sense, which he kept in play for only a brief
time, in some early drafts for what eventually became *Being and*

4. Lion, *The Prague Ghetto*, 28.

Time.[5] During this time *das Vorbei* is the name of death: Dasein's being toward its own death is a matter of its comporting itself to its own goneness, *das Vorbei*. It is a matter of its running up against its own goneness, the future that will never be present. And yet, common sense—or rather, a certain allegedly common sense—insists that what is gone, what is over and done with, is the past; and as soon as one begins to apply this measure, the measure of presence, to *das Vorbei*, it begins to name the past rather than one's ownmost possibility at the limit of the future.

The word might, then, be left suspended, while at the same time being turned responsively to the sight of the old cemetery. Then it would say—bringing everything back now, finally, to the native tongue: dead and gone. And yet, also: brought back—in the word itself, in the appeal to which it responds, in the accord of the word to the appeal. Brought back, even if still only as past, as dead and gone.

5. Most notably in the lecture that Heidegger gave in July 1924 to the Marburger Theologenschaft: *Der Begriff der Zeit* (Tübingen: Max Niemeyer, 1989), 17–21. This is the lecture that Gadamer has called the *Urform* of *Being and Time. Das Vorbei* still occurs with the same meaning in the much expanded manuscript that Heidegger prepared in the months following the lecture with a view to publication. The plans for publication did not work out, for reasons explained in detail by Theodore Kisiel, "Why the First Draft of *Being and Time* Was Never Published," *Journal of the British Society for Phenomenology* 20 (1989), 3–22. The word, as a designation for death, subsequently disappears from Heidegger's texts.

3

FROM TOWER TO CATHEDRAL

Hegel said almost the same of art, that it is for us something past.

His declaration of the pastness of art is in play from the very outset of the lectures on fine art (*schöne Kunst*) that he presented several times during the 1820s at the University of Berlin. For these lectures Hegel used the title *Aesthetics*, as did his student H. G. Hotho, who edited the lectures after Hegel's death and published them for the first time in 1835.[1] Yet Hegel grants the title only as a concession to common speech, noting at the very beginning that it "is not wholly suitable, since *aesthetics* means more precisely the science of sense, of feeling [*Wissenschaft des Sinnes, des Empfindens*]" (*A* 1:13). Properly speaking, aesthetics would regard the work of art strictly from the perspective of the feeling evoked by it, and Hegel refers in fact to the school of Wolff in which works were regarded in terms of the feelings of pleasure, admiration, fear, or pity that

1. Hegel first lectured on aesthetics in Heidelberg in 1818. In Berlin he presented his lectures on aesthetics four times, in 1820–21, 1823, 1826, and 1828–29, using throughout the Berlin period the same notebook, adding to it numerous revisions and notes as he continued to rework and expand the lectures. This notebook along with several sets of student notes provided the basis for the edition of the *Aesthetics* that Hotho published in 1835, four years after Hegel's death. In Hotho's edition no differentiation is made between versions of the lectures given in different years. In 1842 Hotho published a slightly revised edition, and this second edition has provided the textual basis for subsequent discussions of the work. Today both Hegel's notebook and most of the student notes used by Hotho are lost; the problems of preparing a critical edition are therefore immense, and it is unlikely that such an edition will appear in the near future. But there remains at least enough material to allow serious criticism of Hotho's editorial work, and there are some who have criticized it quite severely, most notably Annemarie Gethmann-Siefert (see "Ästhetik oder Philosophie der

they produced. Such an aesthetic conception of art is what came subsequently to be grounded through Kant's theory of aesthetic judgment: Kant delimits aesthetic judgment as an interplay of understanding and imagination that comes into play in such a way as to connect the aesthetic, sensible apprehension of the work with the feeling of pleasure that will then be said to have been evoked by the work. By thinking this essential connection between the sensible affection and the production of the feeling of pleasure, Kant grounds the aesthetic conception of art. This grounding has two major consequences. First, it allows Kant to distinguish rigorously between aesthetic judgment and cognitive judgment: in aesthetic judgment there is harmonious play between imagination and understanding, whereas in cognitive judgment there is subsumption of the imaginatively synthesized manifold under the concepts of understanding.[2] More generally Kant's grounding of aesthetics serves to introduce a fundamental differentiation between beauty or art, on the one hand, and knowledge or truth, on the other: "The aesthetic judgment contributes nothing toward the knowledge of its objects."[3] However, the second consequence works against this dif-

Kunst: Die Nachschriften und Zeugnisse zu Hegels Berliner Vorlesungen," *Hegel-Studien* 26 [1991], 92–110). I am grateful to Professor Gethmann-Siefert for allowing me to compare some of the notes covering Hegel's discussion of architecture with the corresponding presentation in Hotho's edition. Such comparison makes it clear that the text published by Hotho is more extensive, not only filling out the particular discussions but including, for example, specific discussions not found in the particular sets of notes examined. Whether this discrepancy only reflects differences between the versions of the lectures given in different years remains to be decided, probably only after considerably more material has been transcribed and critically examined. Gethmann-Siefert points out also that Hegel's conception of the character of art as past (*Vergangenheitscharakters der Kunst*) was considerably sharpened in the 1828–29 version of the lectures, corresponding to systematic changes that Hegel made in the relevant sections of the 1827 version of the *Encyclopedia*; she notes that this sharpening of the thesis of the end of art can be traced in the three remaining sets of student notes to the 1828–29 lectures.

2. The determination of aesthetic judgment and the differentiation of it from cognitive judgment are most succinctly stated in §VII of the Einleitung to the *Kritik der Urteilskraft*. I have discussed the former in some detail in *Spacings—of Reason and Imagination*, 87–99.

3. *Kritik der Urteilskraft*, Einleitung, §VIII.

ferentiation: precisely because Kant makes judgment the grounding
link in aesthetic comportment, precisely because he makes judgment
the ground linking the sensible-imaginative apprehension of some-
thing beautiful to the production of a feeling of pleasure, he forges
a connection between the aesthetic and the cognitive. For however
rigorously he distinguishes aesthetic judgment from cognitive judg-
ment, he continues to regard judgment as belonging to the powers
of cognition (*Erkenntnisvermögen*).[4] Thus, Kant's differentiation
of beauty from truth proves to prepare for a new connection in
which beauty is allied with a broader sphere of truth, ultimately that
of the supersensible, practical subject, one who can rise to the ap-
prehension of "beauty as a symbol of morality."[5] The result is, then,
that Kant's very grounding of aesthetics proves to be an undermin-
ing of the conception of art as the object of mere sensibility. In the
end, Kant's grounding of aesthetics is also an undermining of aes-
thetics, an undermining that the *Critique of Judgment* effectively
carries through.

Little wonder, then, that at the outset of his lectures Hegel marks
a break with aesthetics, insisting that the proper title would be, in-
stead, philosophy of art or philosophy of fine art (*Philosophie der
schönen Kunst*). In the concept of art that Hegel develops in his
lectures, it is a matter not only of sense and feeling but also of truth.
Indeed, it is precisely this double bond that leads Hegel to declare
the pastness of art.

Art is for us something past. More than a century later Heidegger
will insist that a decision has still not been reached regarding this
declaration, that the pastness of art remains still undecidable. A
measure, no doubt, of the decisiveness of Hegel's lectures, which
Heidegger will call "the most comprehensive reflection on the es-
sence of art that the West possesses" (*UK* 68).

Art is for us something past. Art, says Hegel, "no longer fulfills
our highest needs. . . . Art no longer grants that satisfaction of spiri-
tual needs that earlier ages and nations sought in it and found in it

4. See Kant's Table of the Higher Powers of the Soul, at the end of the Ein-
leitung to the *Kritik der Urteilskraft*.

5. Ibid., §59.

alone." Thus he concludes: "In all these respects art, considered in its highest determination [*Bestimmung*], is and remains for us something past [*ein Vergangenes*]" (*A* 1:21f.). Hegel knew of course that the great art of the past would continue to speak to mankind; but its speech would have become foreign, no longer satisfying the highest needs of mankind. Such art would be past in a double sense, doubly an art of the past, stemming from a past age and sufficient to the highest needs of past ages only. Hegel also knew of course that works of art would continue to be created in the future; but he insisted that there would never be, in the most decisive sense, an artwork of the future, but only artworks that, even before being created, would already have become something past. To all art, past and future, Hegel would say and would have humanity say: *nicht mehr*, "we bow our knees no longer" (*A* 1:110). Art is something past. Art is *vorbei*, dead and gone, as far as the highest needs of mankind are concerned. Even if its ghosts return. Even if they spring up from the soil of the future.

Yet along with the ghosts of art there are other specters whose words do still speak to the highest needs of mankind, now and into the future, specters that do not merely return to haunt a world to which they no longer truly belong, specters in whom, on the contrary, the spirit of art is reborn in new shapes, speaking new tongues. These specters both banish art and replace it. In them the spirit of art is reborn, and this resurrection of what is otherwise dead and gone is the highest testimony that, in Hegel's words, "the life of spirit is not the life that shrinks from death and keeps itself untouched by devastation, but rather the life that endures it and maintains itself in it. It wins its truth only when, in utter dismemberment, it finds itself." Such is the magic of spirit, its magical power (*Zauberkraft*), that from the negativity of death it can bring itself back into being: "Spirit is this power only by looking the negative in the face and tarrying with it. This tarrying is the magical power that turns it around into being."[6] What that magic produces from art is religion and philosophy. These are the other shapes of spirit

6. Hegel, *Phänomenologie des Geistes*, ed. Wolfgang Bonsiepen and Reinhard Heede, vol. 9 of *Gesammelte Werke* (Hamburg: Felix Meiner Verlag, 1980), 27.

that come to displace art, sealing its consignment to the past while
themselves arising from its very dismemberment.

All three figures belong to the same sphere. But within the limits
of the *Aesthetics*, Hegel does not trace the turnings of these circles
so as to delimit the figures in a rigorous way, that is, so as to display
the magic by which spirit returns from death to life in ever higher
shapes. Within the limits of the *Aesthetics*, even the concept of art
is merely taken up lemmatically, not rigorously derived as such; it is
"a presupposition given by the system of philosophy" (*A* 1:35). And
so, at the outset Hegel delimits the sphere common to art, religion,
and philosophy in a way that forgoes reiterating the circlings of
spirit, that presupposes the rigorous deduction outlined in the *En-
cyclopedia*. The sphere common to the three figures he simply iden-
tifies as that in which are expressed the most comprehensive truths
of spirit.

How is it that there is need for such expression? What is the spiri-
tual need that art would formerly have satisfied but can no longer
satisfy? What is this need that now finds its satisfaction in religion
and philosophy, perhaps only in philosophy? It is a universal need,
indeed an absolute need, one that can find its highest satisfaction
only in absolute forms of spirit, only in the expression of the most
comprehensive truths of spirit. Here is Hegel's account of this need:
"The universal and absolute need from which art (on its formal side)
springs has its origin in the fact that [*findet seinen Ursprung darin,
dass*] man is a *thinking* consciousness, i.e., that man draws out of
himself and puts *before himself* [für sich] what he is and whatever is
at all. Things in nature are only *immediate* and *single*, while man as
spirit *doubles* himself [verdoppelt *sich*], in that, first of all, he *is* as
things of nature are, but then he is just as much *for himself* [für
sich]; he intuits himself, represents himself, thinks, and only
through this active placing of himself before himself [*dies tätige
Fürsichsein*] is he spirit" (*A* 1:41). One could read this passage as
Hegel's account of the origin of the work of art. That origin lies
in the determination of man as doubling himself: as spiritual, man
is essentially self-doubling (so that he not only *is*, like things of na-
ture, but also is *for himself*), and art—like religion and philosophy—
is a way in which he actually comes to double himself, to be present

to himself in his double. Art—like religion and philosophy—originates in order that man's essential determination as self-doubling might be fully actualized.

One could also read the passage as Hegel's account of the superiority of artistic beauty over natural beauty: because things in nature are only immediate and single, their appearance cannot actualize the self-doubling of spirit. However much one may speak of their beauty, such things do not provide man with a (self-doubling) representation of himself as self-doubling; they do not provide a scene for his active placing of himself before himself. This is why Hegel can declare nature "necessarily imperfect in its beauty" and insists that his proper topic in the *Aesthetics* is "the beauty of art as the only reality adequate to the idea of beauty" (*A* 1:146). This is why he can decree, even before turning to the investigation of natural beauty, that a painting of a landscape has a higher rank than the mere natural landscape: "For everything spiritual is better than any product of nature" (*A* 1:40). Not that Hegel will go so far as simply to deny genuine natural beauty: especially in the living organism, in the enduring and overcoming of the contradiction[7] between the body with its various members and the animating ideal unity, there is an anticipation of the self-doubling that will be actualized only through the transition from nature to spirit, fully so only in the absolute forms of spirit.

And yet, there is no more than anticipation: the intuition of nature as beautiful goes no further than a foreshadowing (*Ahnung*) of the self-doubling that art will prove capable of actually presenting. Hegel allows even that "in another sense we speak further of the beauty of nature [even] when we have before us no organic living creature, as, for example, when we look at a landscape." In such an instance there is no organic articulation of parts but only, on the one hand, a variety of objects ("the contours of mountains, the windings of rivers, groups of trees, huts, houses, towns, palaces,

7. "Yet whoever claims that nothing exists that carries in itself a contradiction in the form of an identity of opposites is at the same time requiring that nothing living exist. For the force of life, and still more the power of the spirit, consists precisely in positing contradiction in itself, enduring it, and overcoming it" (*A* 1:125).

roads, ships, sky and sea, valleys and chasms") and, on the other hand, an external harmony that we find pleasing or impressive (*A* 1:136f.). And yet, the very reserve of such an account cannot but make one wonder whether Hegel is really granting that a landscape can be genuinely beautiful or whether he is only pointing to the quite deficient beauty, an improper—almost sham—beauty, that underlies our loose talk about beautiful landscapes. One might also wonder about such beauty of landscapes in view of Hegel's discussion in what, though marked as a separate section, may well be taken to continue what Hegel has just said of landscapes: this subsequent discussion focuses on the capacity of the beauty of nature to arouse moods (*Stimmungen des Gemüts*) and to exhibit a harmony with our moods. His examples: "the stillness of a moonlit night, the peace of a valley through which winds a brook, the sublimity of the immeasurable, churning sea, the restful immensity of the starry heaven." Hegel concludes: "Here the significance [*Bedeutung*] no longer belongs to the objects as such but is to be sought in the mood they arouse" (*A* 1:136)—as if their beauty could accomplish no more than to evoke moods, as if it were a beauty that presented nothing of the truth of the objects, which would be to say virtually not beauty at all. The legitimacy of such beauty becomes even more questionable if one takes into account Hegel's insistence on the inadequacy of plants to reflect even what animate life can present (the plant's "activity is always drawn out into externality") (*A* 1:140); to say nothing of the utter defectiveness that Hegel ascribes to what he calls "dead, inorganic nature" (*A* 1:124).

For example, stone—of which Hegel says almost nothing in his discussion of natural beauty, mentioning it only in a passage where he contrasts the particular parts of a house ("the individual stones, windows, etc.") with the members of an organism whose unity gives them a reality not possessed "by the stones of a building" (*A* 1:126). At most, Hegel could have allowed stone in nature the kind of defective beauty that he accords to any sensible material that is pure in shape, color, or whatever other qualities might be relevant in view of its reception of possible forms (*A* 1:144f.). Stone would merely belong to "dead, inorganic nature"—even though, in the most rigorous determination of the word, stone is not dead, not

dead as are those whose graves it can mark. What cannot have lived cannot have died, cannot be dead—assuming that anything can *be dead*, that death is not the utter exclusion of being, from being. Only if *life*, ultimately as life of spirit, life as the spiritual endurance of contradiction—only if life is made the measure, will one then say, without further ado, that stone belongs to dead nature. But then, stone in nature will have been, in advance, appropriated to what can still be called, even if in an extended sense, experience.[8]

For example, the stone of a glacier-covered mountain peak.

In July 1796, while employed as a private tutor in Bern, Hegel set out with three other tutors on a walking tour in the Alps. During the tour he kept a very detailed diary.[9] From this diary one learns a great deal about his response to the mountainous landscape, in particular, that for the most part he was not so moved by it as—having once read Meiner's *Journeys in Switzerland*—he had expected to be. For example, he tells of how the snow-covered peaks in the region of the Jungfrau failed to make the impression that had been expected, how "they did not excite the feeling of immensity and sublimity" (*B* 384). He tells also of an occasion when he and his companions came within a half-hour's walk of a glacier, only to find that the sight offered "nothing interesting": "One can only call it a *new kind of sight, which however gives to the spirit no further occupation whatsoever* except to be struck at finding itself so close to masses of ice during the extreme heat of the summer" (*B* 385). He says of some other mountains seen during the tour (drawing his words from the *Critique of Judgment*, almost as if to disconfirm what Kant says, especially about the sublimity of "shapeless masses of mountains piled in wild disorder upon one another with their pyramids of ice"): "Neither the eye nor the imagination finds in these formless masses any point on which the former could rest with satisfaction or where the latter could find occupation or play. . . . In the thought of the permanence of these mountains or in the kind of

8. See *Phänomenologie des Geistes*, 60. Hegel's word is of course *Erfahrung* rather than *Erlebnis*.

9. "Bericht über eine Alpenwanderung," in *Frühe Schriften* I, ed. Friedhelm Nicolin and Gisela Schüler, vol. 1 of *Gesammelte Werke* (Hamburg: Felix Meiner, 1989), 381–398. Hereafter: *B*.

sublimity that one ascribes to them, reason finds nothing that impresses it, that elicits from it astonishment and wonder. The look of these eternally dead masses gave me nothing but the monotonous and, in the end, boring representation: *it is so* [es ist so]" (*B* 391f.)—little more, then, than simply being, pure being, with little further determination, hardly more or less than nothing.

The one major exception seems to have been the sight of a waterfall: "Through a narrow rock-cleft, the water presses forth from above, then it falls straight downward in spreading waves, waves that draw the gaze of the spectator ever downward but which he still cannot fix or follow, for their figure [*Bild*], their shape dissolves at every moment, is forced into a new one at every moment, and *in this fall one sees always the same figure and sees at the same time that it is never the same*" (*B* 388). Hegel's celebration of this sight results from its being a natural image of life: "the eternal life, the powerful mobility in it" (*B* 388). Here one recognizes of course the same schema operating as in the *Aesthetics*. And yet, in precisely this context in the diary, Hegel insists on the inadequacy of any painting to represent what, at least in the case of the waterfall, one finds presented in nature: "*The sensible presence of the painting* does not allow the imagination to expand the represented object. . . . When we hold the painting in our hands or find it hanging on a wall, then the senses cannot do otherwise than measure it by our size, by the size of the surrounding objects and find it small. . . . Furthermore, even the best paintings necessarily lack what is most alluring, what is most essential in such a spectacle [*Schauspiel*]: the eternal life, the powerful mobility of it" (*B* 388). At least with respect to this spectacle, it seems that nature surpasses art in its presentative power, that nature presents something essential and does not merely foreshadow a presentation that only art will properly accomplish; it is as though there were a kind of natural reserve, an excess, that art would be unable to tap. But in the account of natural beauty given in the *Aesthetics*, it is difficult to discern even the slightest trace of any such reserve.

But now, for now, following Hegel, let me put aside nature and its mere foreshadowing of that beauty that comes properly into play in art, which—along with religion and philosophy—can express the

most comprehensive truths of spirit. And yet, even in turning to art and marking its differentiation from religion and philosophy, one cannot put nature entirely aside. For what distinguishes art from the other two forms is its link with nature, even though with a nature transformed, no longer nature as such but nature in the form of the artwork. What distinguishes art from those other forms is that it presents the truth of spirit in sensible form, in a configuration palpable to sense, bringing these most comprehensive truths nearer to sense and feeling. But precisely for this reason, art is not the highest shape in which to express such truth. Because of its sensible form, it is limited to a specific content: art can present spirit only down to a certain level, not in its depth. The multidirectionality of Hegel's discourse, even the contrariety of its directionalities, should not go unnoticed here: the *higher* shapes of spirit are those that express the *deeper* levels of the truth of spirit, and the depth of spirit to which art cannot reach is, in turn, the most *interior*, the inwardness of spirit, which is thus opposed to the exteriority in which art is at home. For art is at home only at the level at which spirit can go forth truly into the sphere of sense, remaining adequate to itself there, submitting fully to enclosure within a sensible configuration. Hegel refers to the Greek gods as constituting such a content, in distinction from what he identifies as "the deeper comprehension of truth" achieved through Christianity and the development of reason, a comprehension of spirit at a depth where, as he says, "it is no longer so akin to sense" as to be appropriable to such material as art has for configuring it (*A* 1:21). The absolute inwardness of spirit proclaimed by Christianity occurs at that depth, as does the modern detachment of the universal from the sensible, the separation by which the universal can come to govern the sensible as a rational law or maxim outside it. Because art cannot reach to this depth unfolded in the spirit of the modern world, it is for us something past.

Nonetheless, art does—even today, even now that it is for us something past—present the truth of spirit. It presents spirit in the guise of spirit, not in the guise, for example, of nature. It presents spirit as spirit, even if not in its full depth. This is why it belongs to the sphere of absolute spirit, along with religion and philosophy. Indeed, at those junctures in the *Aesthetics* where Hegel sets forth

in full generality the vocation of art and the essence of art as determined by that vocation (*die Bestimmung der Kunst*—in the double sense), he invariably refers to the presentational character of art, to its character as *Darstellung*. In one formulation, it is the vocation of art to present "the truth in the form of sensible artistic configuration [*der sinnlichen Kunstgestaltung*]" (*A* 1:64). Or, again: "Art has no other vocation but to bring before sensible intuition [*sinnliche Anschauung*] the truth as it is in spirit" (*A* 2:16). Both formulations mark clearly the double bond of art: on the one hand, its bond to the truth of spirit, which it is bound to present; on the other hand, its bond to the sensible, in an artistic configuration of which it is bound to shape its presentation. One of the most remarkable accomplishments of the *Aesthetics* is the way in which it goes about systematically determining the specific character of the sensibleness (*Sinnlichkeit*) to which art is bound. Even at the most general level, where the differentiation between the various forms of art and that between the individual arts has not yet come into play, Hegel rigorously distinguishes the artistic bond to the sensible from other types of relatedness that spirit can assume to the sensible. Among those other, nonartistic types of relatedness he includes: first, sensible apprehension, which merely looks on; second, desire, which uses and consumes things, gaining self-realization in them; and, third, theoretical intelligence, which goes straight for the universal, detaching it so thoroughly that the sensible loses all further relevance. By contrast, the artistic configuration, the artwork, is cherished, yet without becoming an object of desire. It counts neither in its immediate material existence nor in its pure universality, but rather as shining (*Schein*).

With this word Hegel overturns a decisive character of art, overturns into a positive determination a character of art that has almost always been taken to discredit it and to demonstrate its unworthiness in relation to philosophy. In part, the overturning is just a matter of restoring to *Schein* its range of senses and connections, so that, instead of hearing in it only the sense conveyed by *illusion* or *deception*, one hears in it an affiliation with *das Schöne* and extends its senses to include: shine, look, appearance, semblance, as well as illusion and deception—at least these, in a reconfiguration that can

perhaps be expressed somewhat by the translation *shining*. But it is also a matter of according to shining a broader positive determination. The discrediting of art because of its character as shining would be legitimate if shining were something that ought not to be (*das Nichtseinsollende*). But, says Hegel, reiterating a decisive development in the Logic of Essence:[10] "*Shining* itself is essential to *essence*." In less austere terms: "Truth would not be, if it did not shine and appear, if it were not *for* [some]one [*für Eines*], *for* itself, as well as for spirit in general too" (*A* 1:19). Through its shining, the work of art can let truth be, can let truth appear; through its shining, it can let appear a higher truth than any that could appear in mere nature, however beautiful.

Near the beginning of the *Aesthetics* there is a remarkable passage in which Hegel tells how the sensible enters into the artwork: "For in the sensible aspect of the artwork [*im Sinnlichen des Kunstwerks*], spirit seeks neither the concrete material stuff, the empirical inner completeness and development of the organism, which desire demands, nor the universal and purely ideal thought. Rather, what it wants is sensible presence [*sinnliche Gegenwart*], which indeed should remain sensible, but freed from the scaffolding of its mere materiality. Therefore, the sensible in the artwork [*das Sinnliche im Kunstwerk*], in comparison with the immediate existence of things in nature, is elevated to pure *shining* [*zum blossen* Schein], and the artwork stands in the *middle* between immediate sensibleness and ideal thought" (*A* 1:48). In the artwork the sensible is present in its pure shining. Hegel calls this pure shining "the wonder of ideality," contrasting it with "prosaic reality," portraying it as "a mockery . . . and an irony toward what exists externally and in nature" (*A* 1:164). Its distance from nature is attested by the fact that the sensible aspect of art is related only to what Hegel calls the two theoretical senses, sight and hearing, in distinction from smell, taste, and touch, which have to do with the sheer materiality of immediate sensible presence. Art replaces the solid materiality of nature with a mere

10. *Wissenschaft der Logik*, Erster Band: Die Objektive Logik, ed. Friedrich Hogemann and Walter Jaeschke, vol. 11 of *Gesammelte Werke* (Hamburg: Felix Meiner, 1978), 244ff.

surface of the sensible, a shadow-world of shapes, sounds, and sights, mere schemata that have a power that nature can only foreshadow: the power "to evoke from all the depth of consciousness a concord and echo [*Anklang und Wiederklang*] in the spirit" (*A* 1:49). It is in this way that the sensibleness of art comes to be spiritualized, the sensible and the spiritual being made as one through the activity of artistic phantasy.

One could say that it is the sensible, shining character of the artwork that destines art to have become something past. And yet, art's attachment to the sensible produces such an effect only because the sensibleness of art is spiritualized, only because art is also bound to present the most comprehensive truths of spirit, to present the idea in the most comprehensive and elevated sense (so that its beauty is determined as "sensible shining of the idea" [*A* 1:117]). Because art cannot, as sensible, present the truth in its full depth, art is destined by its very constitution to become something past. Once the full depth of spirit has unfolded, art will have become something past. Hegel's philosophy, the full circling of the *Encyclopedia*—more precisely, *Wissenschaft* in its completion, the Encyclopedia itself in distinction from the text that outlines it—would mark the completion of that unfolding. Now that the very depths of spirit have been brought forth into the light of day, the mere surfaces and shadow-worlds of art can no longer satisfy mankind's highest needs. The dynamics of art's double bond make it a double bind. Caught in this bind, art is consigned to the past. For us—for the *we* that would recollect and complete spirit's unfolding—art has become something past. And for we who remain in the wake of that completion, we who continue the vigil, the pastness of art cannot but loom darkly over us like a monstrous question mark.

Recollecting the entire history of art, the *Aesthetics* marks the pastness of art in various connections. For that becoming-past—the end of art, as it were—is no simple event that could be located on a linear time-scale, at some point in time where art would have become, from then on, something past. Rather, art's becoming-past is an end that is divided, that is split and temporally deployed by the very lines that delimit what art is. For in the art of poetry, for instance, the passing that would consign art to the past is always al-

ready broached: poetry is not tied down to sensible material in the decisive way that other arts are, and, as its sound dies away, the passing enacts a self-transcendence of art, letting art pass away and become something past (see *A* 1:94). In romantic art there is also operative a certain self-transcendence, a passing that will have come into play with the end of classical art (see *A* 1:87).

The Hegelian recollection gathers art in its history in such a way as to distribute it along two axes, that of its forms (symbolic, classical, romantic) and that of the individual arts (architecture, sculpture, painting, music, poetry). Throughout this recollection the end is in play, and there is perhaps no corner of the *Aesthetics* where one cannot at least catch a glimpse of the eventual pastness of art. For the discourse of the *Aesthetics*, for the discourse that gathers and distributes art in its history, for the recollective *we*, art has already passed away. It is almost as if that discourse were an extended funeral oration. It is almost as if the *Aesthetics* were an inscription written for the gravestone that would memorialize art, calling it back now that it is dead and gone.

Stone figures prominently in that inscription, especially in what it says of the beginning.

Art, recollected in its history, displays its pastness. Most remarkably, it displays that pastness even in its beginning, in the stone (that most ancient material) from which art in its beginning shapes much of its work. For in the Hegelian recollection of its history, architecture counts as the beginning of art. Within the recollection the primary concern in this regard is to establish the beginning of art by deriving it from the very concept of art, to show from the thing itself (*durch die Sache selbst*) that architecture constitutes the beginning of art (*A* 2:17). This, says Hegel, is what we—the recollective *we*—have to do (*A* 2:24). Yet the initiatory character of architecture pertains not only to the order of the concept: Hegel insists equally that architecture be recognized as the art coming first in existence, as an art that "began to be developed earlier than sculpture or painting and music" (*A* 2:24). And yet, in beginning his discussion of the individual arts with this beginning, indeed with its beginning,

with the beginning of the beginning, Hegel is careful to interrupt all tendencies to valorize such beginnings: he declares the simple beginning (*der einfache Anfang*) something quite insignificant and mocks those who harbor the dim notion that the beginning reveals the thing itself in its concept and origin (*in ihrem Begriffe und Ursprunge*), as if one could explain the origin of painting, for instance, by telling stories of a girl who traced the outline of her sleeping lover's shadow (*A* 2:23). The beginning is impoverished in comparison with what is to come, and architecture is the beginning of art because in architecture art has not yet "found for the presentation of its spiritual content either the adequate material or the corresponding forms" (*A* 2:17); in this beginning no more than an external relation between content and presentation can be achieved. It is not in the architectural beginning, least of all in the beginning of architecture, that one is to seek the origin of the artwork.

But how does architecture display the pastness of art? It does so by showing an essential propensity to be appropriated to religion, which will finally, in the form of Christianity, transcend art so decisively as to consign it to being something past. The connection is there from the beginning: "The beginning of art stands in the closest connection with religion" (*A* 1:311). This connection is indicative also of the origin of art, even though it is imperative to maintain a rigorous distinction between beginning (*Anfang*) and origin (*Ursprung*): art begins in relation to a certain origin, and, though in the development into higher forms the beginning is left behind, becomes past, the origin remains operative and continues to determine art throughout its entire course. What, then, is the origin of art? Or rather, what is art's first origin (*erster Ursprung*), as Hegel calls it in order to focus on its operation at the beginning? Can one say that art originates from religion and that this is why it is destined eventually to be overturned into religion? Only within certain limits: for the origin of art is something that occurs not only in religion, even if it is inseparable from religion. Ultimately, this origin is nothing less than the essentially self-doubling character of spirit itself, and what it originates first of all is the need to actualize this character, the need for spirit actually to become for itself. But in the beginning, as the *first* origin, the doubling of spirit is actualized

merely in man's coming to have a certain sensible apprehension of the divine, the absolute. At first, when art has not yet come upon the scene, the absolute is beheld only in its most abstract and poorest determinations: man merely intimates its presence in natural phenomena. Art originates when this impoverished natural revelation comes to be replaced and man no longer beholds the divine merely in the actually present things of nature. Art originates when man produces through his own resources (*aus sich selber hervorbringt*) a new object, one capable of presenting a spiritual content that does not appear in natural things. Art begins as an interpreter that first gives shape to the content of religion. And art remains the sensible presentation of that content even after the beginning has long since been left behind.

What does art produce in the beginning? How does it reconfigure natural reality so as to produce something capable of presenting a spiritual content, a meaning (*Bedeutung*), that does not appear in natural things? In the beginning artistic production is impoverished, severely limited both by the material that it reshapes and by the form appropriate to such material: the material is inherently nonspiritual, namely, heavy matter taken directly from nature and shapeable only according to the laws of gravity, while the form involves nothing more than shaping and binding together this matter in regular and symmetrical patterns. The limitation that belongs thus to architecture, to its very concept, submits it to a peculiar logic, a logic that essentially determines the entire development of architecture.

But into what does architecture reconfigure nature? What does it produce by shaping and binding together the masses of heavy matter found in nature? It reconfigures, says Hegel, "the external environment of spirit" (*A* 2:24), reshapes it into a surrounding more appropriate to spirit. But this precisely is its limitation: merely by shaping and binding together heavy matter, it can never produce anything more than a surrounding for spirit. Hence the peculiar logic of architecture: because its product provides—and can only provide—an enclosure for spirit, that product is prohibited from having spirit within itself. Because it (only) encloses spirit within itself, it excludes spirit from itself and remains itself excluded from

bearing within itself its meaning, the spiritual content that is presented in conjunction with it. Hegel says that the vocation of architecture is to fashion a beautiful enclosure (*Umschliessung*) for the spirit as already present, namely, in the guise of man or the divine image he will set up in the enclosure. But, then, the architectural product does not bear its meaning or purpose in itself but has it only in the men or images it will enclose. Precisely when the architectural work accords fully with its concept (that of enclosing spirit), it has its meaning outside itself. Incapable of endowing the spiritual with an appropriate existence, "it can only reshape the external and spiritless into a reflection [*Widerschein*] of the spiritual" (*A* 2:51). The architectural product cannot itself present spirit, cannot present spirit in and through its own shining; it can only enclose the spiritual, providing a shell (*Hülle*) for the statue of the god, for another artwork that another art, one outside architecture and unbound by its limitations, will have shaped into an appropriate sensible presentation of spirit. In contrast to the sculptural work, the architectural shell can at best only reflect the shining of the divine image it houses.

Yet, in the beginning the architectural work cannot have had its meaning outside itself in this manner. For the very concept of beginning prescribes that the beginning must be "something immediate and simple" (*A* 2:25), hence excluding that separation (purpose/means, meaning/enclosure) that the very concept of architecture necessitates. Hence, in the beginning architecture can have erected only works with independent meaning, works bearing their meaning within themselves rather than having it outside in something they would enclose. The first works of architecture must, then, have been simple and integral, like inorganic sculptures. And yet, in bearing their meaning in themselves, such works are not at all superior to those later ones in which the separation comes about. On the contrary, the first works are not yet even adequate to the concept of architecture: rather than relating in a genuinely architectural way to a meaning outside themselves (enclosing and reflecting it), they relate to their meaning only symbolically. Even if carried within them, their meaning is even more external to them than in the architecture in which the essential separation comes into play.

Only when architecture comes to build an enclosure for spirit will it be in accord with its concept. This occurs with the transition from symbolic to classical architecture. But then the separation will have come into play, and the architectural work will serve an aim, a meaning, that it does not have in itself. Precisely when it becomes most adequate to its concept and produces its most perfect works, architecture itself will have been, as Hegel says, degraded (*herabsetzt*) into providing the enclosure for spiritual meanings quite independent of architecture as such. The perfection and the degradation of architecture are realized at the same time, in the same works: the Greek temple. The temple is made to serve the purpose of enclosing the statue of the god, bringing architecture to full realization at the very moment that it is submitted to a religious purpose external to it and thus itself put down, degraded. In this degradation and in the coincidence of degradation and perfection, the temple displays the pastness to which art is destined.

The temple is also beautiful, even though it cannot itself endow the spiritual with an adequate existence and let spiritual meaning shine forth from itself, in the shining of its stone. Just as perfection and degradation coincide in the temple, there is also in it a certain coincidence or crossing of beauty and purposiveness. Its beauty is its purposiveness—or, more precisely, its beauty lies in the way that "its one purpose shines clearly through all its forms" (*A* 2:50). Incapable of presenting spirit through its own shining, the temple lets its shining present that purposiveness by which it serves another shining, one that is capable of presenting spirit itself. In letting its purposiveness shine forth, the temple is beautiful, indeed as beautiful as an architectural work can be.

The purpose is to provide enclosure for spirit, for the statue in which the god shines forth in his presence. But to provide enclosure, even open enclosure, requires bearing weight, providing support. The distinctiveness of Greek architecture lies in its way of giving shape to this supporting as such, namely, by employing the column as the fundamental element. It is preeminently in this way, in the column, that the temple lets its purposiveness shine forth, and this is why Hegel could declare of the Greek columnar orders: "Neither earlier nor later was anything discovered more architecturally beau-

The Temple of Hera II, so-called Basilica.
Paestum. 6th century B.C.

tiful or purposive" (*A* 2:64f.). Not only the column itself, but also its pedestal and capital let its purposiveness shine forth: beginning and ending are determinations belonging to the very concept of a supporting column, and these determinations are precisely what comes to shine forth in the pedestal and the capital. Whatever material may have been used in the earliest stages, certainly the great classical temples to which Hegel refers—he mentions the Ionic temple at Ephesus and the Doric temple at Corinth, also the Doric temple at Paestum, perhaps the same one that will command Heidegger's attention a century later, though one cannot be sure, for there are in fact three temples at Paestum, two in the Doric style, the other a mixture of Doric and Ionic—certainly such temples are built of stone. Especially in the shining of the stone columns the beauty of such temples is manifest. In the very same stone, shaped, as it is, into a shell for the spacing of religion, there is displayed the pastness of art.

In its very realization the architectural work is reduced to a mere shell for something other, thus put down, degraded, made past at the very moment that it is present in its perfection. The specific pastness of architecture is thus determined by its character as a shell for something other, by the concept of the architectural work as providing an enclosure for spirit. The enclosure (*Umschliessung*) closes around that other, closes off (though perhaps not entirely) the space in which that other is set, shapes that space. But only if the enclosing merely serves, in a completely external fashion, a purpose that is essentially other, a meaning that is outside it precisely in being enclosed in it—only in this case will classical architecture be degraded and in this way made past in its very moment of presence. It is a question, then, of whether the epiphany of the god, his shining forth in the statue set in the temple, is simply other than the shaping of the space of the temple. Or whether that spacing belongs integrally—and not just as an external means—to the epiphany. It is a question of whether the temple merely encloses a space (as a space might be enclosed even in nature) or whether it encloses in such a way that the closedness of the space makes it a space of epiphany, a space in which the god, imaged in the statue, can appear. One could extend the question beyond classical architecture, even beyond the entire course of architecture as Hegel traces it, by diverting the concept of enclosure into that of shelter and by then regarding the vocation of architecture as one of sheltering. Even sheltering humans from the elements is more than an external means in service to something essentially other and independent. For human life is fundamentally determined by man's relation to the elements: to the earth, which gives support, lending it even to the edifices that architecture constructs; to the heights of αἰθήρ, to the sky and the sun, which mark the time of life, its course from birth to death. To say nothing of the more obscure sheltering of what is elemental in human life.

With such questions we might begin, within the compass of architecture, to address the monstrous question that looms still as Hegel's legacy, that of the pastness of art. *We*—no longer just the recollective *we* of Hegel's text, now another perhaps, one more vigilant.

But what about the beginning? For architecture does not begin by building classical temples. In the beginning it will have erected edifices bearing their meaning in themselves, though in an impoverished, external, merely symbolic way, edifices in which the separation between enclosure and meaning will not yet have come into play. In the beginning architecture will have been symbolic, its works like inorganic sculptures.

With what material would these first architectural works have been constructed? In the Introduction to his account of architecture, before he begins to discuss the various types, Hegel refers to an age-old dispute (he mentions Vitruvius) as to whether architecture began building with wood or with stone. He grants the importance of the question, conceding that the character of the material affects the fundamental architectural forms. And yet, he justifies putting the question aside—or rather, deferring it—since it is linked to a question of external purposes, wood being used to build huts for men, stone being used for the temples in which images of gods are to be placed. To decide for wood or for stone would be to introduce purposiveness (and the separation between purpose and means) into the beginning where it cannot yet take place, where it cannot yet take over the place that would be built, degrading architecture as such.

Not, then, at the beginning, but only when that degradation comes to be recollected—the perfect degradation exemplified in the Greek temple—only then does Hegel really address the age-old dispute as to whether building began with wood or with stone. It is as though the disjunction, building with wood or building with stone, could be brought into the account only at the point where the separation between purpose and means, between meaning and enclosure, comes into play, providing the schema through which the significance of the disjunction can be systematically formulated. Thus introducing the disjunction, Hegel can then ask about the beginning of classical architecture, can ask: With which material were temples first built? But then he will also ask, retrospectively, about the material with which the first architectural works will have been built. Nowhere does one discern more clearly the recollective character of Hegel's discourse in the *Aesthetics* than in this peculiar retrospection.

When, in the midst of his discussion of classical architecture, Hegel finally takes up the disputed question, he begins by according to wood a certain natural advantage, an appropriateness for building: it does not require extensive workmanship, since it occurs by nature in regular, linear pieces that can be directly put together; whereas stone, not occurring in such a firmly specific shape, must be split and chiseled into shape before the individual pieces can be laid atop one another so as to construct an edifice. Since a great deal of work is required before stone comes to have the shape and utility that by nature wood has from the beginning, building will have begun—so it seems—with wood. And yet, at the very point where Hegel seems ready to settle the dispute once and for all in favor of building in wood, he turns abruptly away from the apparently natural solution to a certain distribution of the two building materials to architecture in each of its three forms, symbolic, classical, and romantic. Here is the point on which the turn is made: since stone is relatively formless at the start, it can be shaped in any and every way, and therefore "it offers suitable material both for symbolic as well as romantic architecture and the latter's more phantastic forms" (*A* 2:55). Wood's natural advantage turns out to pertain only to classical architecture, in which its naturally rectilinear form "proves directly more serviceable for the stricter purposiveness and reasonableness [*Verständigkeit*] that are the basis of classical architecture" (*A* 2:55). Hegel declares, then, contrary to what one would have expected, that building in stone is especially predominant in independent, i.e., symbolic, architecture. In the beginning architecture will have built predominantly in stone—as it will also, hardly less so, when in romantic form it comes to erect Gothic cathedrals. And even if, at some undeveloped stage, classical architecture built temples of wood, Hegel insists that it "does not stop at all at building in wood but proceeds, on the contrary, where it develops into beauty, to build in stone" (*A* 2:55). Hegel grants that in the architectural forms of the temple the original principle of building in wood is still recognizable. Mentioning the temples at Corinth and Paestum, noting that the columns of such Doric temples are, compared with the other orders, the broadest and lowest, Hegel says that "the distinctive character of the Doric style is that it is still nearer the original simplicity of building in wood" (*A* 2:66). The

Ionic temple is different: in it, says Hegel, there is "no longer any indication of a derivation from building in wood" (*A* 2:67).[11] With the development of the column, in which the beauty of the temple is concentrated, there is effaced every trace that would betray that temples were once built of wood. Except in this effaced—and so, finally, ineffective, inconsequential—beginning of classical architecture, it will always have been principally with stone that architecture will have built. Whatever the architectural edifice will have been able to reflect of spirit will have been reflected in the shining of its stone.

But especially in the beginning, in the works of symbolic architecture. In these works the meanings expressed symbolically by the edifices are vague and general representations, various confused abstractions drawn from the life of nature and intermingled with thoughts of the actual life of spirit. The dispersion and manifoldness of such content is such that it resists being treated exhaustively or systematically, and Hegel explicitly restricts himself to bringing together, in as rational an articulation as possible, only the most important of these contents. He proposes to focus on the purely universal views that provide a unifying point for a people. In this connection the architectural edifice itself serves as a unifying point of a nation, as a place around which the nation assembles; at the same time, it expresses symbolically that which primarily unifies men, their religious representations.

The example that Hegel places first—as if it marked the beginning of architecture, indeed the beginning of art as such—is the

11. These points are corroborated by a present-day specialist: "The beginnings of the major stone orders of architecture in Greece can be traced back to the seventh century. In mainland Greece the Doric order was evolved, with simple columns, reminiscent of both Mycenaean and Egyptian types, having cushion capitals, fluted shafts and no bases. The upper works were divided rhythmically into a frieze of triglyphs (the vertical bands) and metopes (often sculptured) which were a free adaptation of the woodwork in these parts of earlier buildings. This was the style popular in the western Greek colonies also. In east Greece and the islands the other major order of stone architecture, the Ionic, borrowed its decorative forms from the repertory of Orientalizing art, with volutes and florals which in the Near East had never graced anything larger than wooden or bronze furniture, or—like the volute capitals of Phoenicia— had never formed an element of any true architectural order" (John Boardman, *Greek Art* [New York and Toronto: Oxford University Press, 1973], 60–62).

Tower of Babel. Its aim and its content Hegel identifies as the community (*Gemeinsamkeit*) of those who built it together, in common (*gemeinsam*). Coming together in a unification that superseded mere familial unity, all the people are to be linked together by this bond, "by the excavated site and ground, the assembled blocks of stone [*die zusammengefügte Steinmasse*], and the architectural cultivation, as it were, of the country" (*A* 2:31). The Tower of Babel both *is* the bond and *expresses* the bond, indicating, though only symbolically, only in an external way, that which ultimately unifies men, the holy. In its assembled stones, the Tower bears its meaning, not because those stones adequately express the meaning but because, at this stage, the distinction has not yet been discerned between the meaning and the edifice that expresses it. The Tower of Babel is both, indistinguishably.

The first move that Hegel traces beyond this beginning is one in which architecture adopts as its content meanings more concrete than that of an abstract unification of all peoples. To express these more concrete meanings, recourse is had to more concrete forms. It is especially at this stage that symbolic architecture becomes like inorganic sculpture, even though its works remain fundamentally architectural and not sculptural. Hence, when the focus of attention and worship becomes the universal life-force of nature and, more concretely, the productive energy (*Gewalt*) of procreation, this content comes to be represented in the shape of animal generative organs. Thus were built, especially in India (Hegel draws here from Herodotus), "monstrous column-like structures of stone" (*A* 2:34), giant phallic columns, expressing the procreative force symbolically. One can say of such a column, as of the Tower of Babel, that it both *is* the meaning and *expresses* the meaning. The distinction remains undrawn, and this is why in the beginning the phallic columns were solid; when, at a later period, openings and hollows were made in them and images of gods placed in these, so that the separation between an inner kernel and an outer shell was introduced, then symbolic architecture was degraded into an architecture with its meaning outside itself, an architecture well on its way to becoming merely a means serving a nonarchitectural purpose. As with the classical temple.

The quasi-sculptural character of such symbolic architecture, its

character as like inorganic sculpture, is more evident in the Egyptian obelisk, which has a purely regular shape rather than a form derived from organic nature. Hegel identifies the meaning of such edifices, the content that they express symbolically, as the rays of the sun. He refers to Pliny as having already ascribed such meaning to obelisks, and he quotes Creuzer's description of them as "sunrays in stone [*Sonnenstrahlen in Stein*]" (*A* 2:35). But the meaning is not something other than the obelisk itself, for its stone both represents the sun-god's rays and catches those rays, shining with their brilliance in such a way that the stones of the obelisk become the sunrays. The shining of its stone both *is* the shining of the sunrays and *expresses* that shining. Sunrays in stone.

But such quasi-sculptural edifices do not for the most part stand alone; they are multiplied and assembled into such compounds as the Egyptian temple-precincts. Hegel takes over and extends (on the basis of contemporaneous research) Strabo's account of these colossal structures, which remain independent, open constructions not yet serving to enclose a religious community or even, in the full sense, a god. Hegel describes the layout of these enormous architecturally ordered collections of quasi-sculptures, summing up his description in these words: "After these sphinx-avenues, rows of columns, partitions with a surfeit of hieroglyphics, after a portico with wings in front of which obelisks and couching lions have been erected, or again only after forecourts or surrounded by narrow passages, the whole thing ends with the temple proper, the shrine (σηκός), of massive proportions, according to Strabo, which has in it either an image of the god or only an animal statue" (*A* 2:37). Such a construction remains architectural and symbolic, indeed remains architectural primarily because it remains symbolic: the individual forms and shapes, the quasi-sculptures, are not expressive through their own symmetry, rhythm, and beauty but express their meanings only symbolically.

And yet, in the Egyptian temple-precinct there are two modifications that serve to distinguish it from the previous works. One of these modifications lies in the fact that "the whole thing ends with the temple proper," that the entire way through the precinct leads to a shrine enclosing an image of the god or at least an animal statue. Here one finds a first trace of the separation that will become

The Alexandrian Obelisk (Cleopatra's Needle).
(Moved to New York in 1881.)

complete when, in classical architecture, the entire architectural work merely serves to provide an enclosure for the statue of the god and, to an extent, for the community of worshippers. But in the present case Hegel is careful to mark the limitation: taking exception to what Strabo says, he insists in effect that in the Egyptian temple one finds only a trace of the temple proper: "But in general

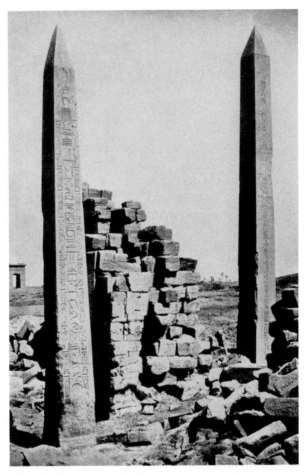

The obelisks at Karnak, Egypt.

the shrines are so small that there is no place in them for a community; but a community belongs to a temple, otherwise it is only a box, a treasury, a receptacle for keeping sacred images, etc." (*A* 2:37).

Though Hegel describes vividly the other modification found in the Egyptian temple-precinct, he does not underline its import as much as one might have expected. The modification consists in

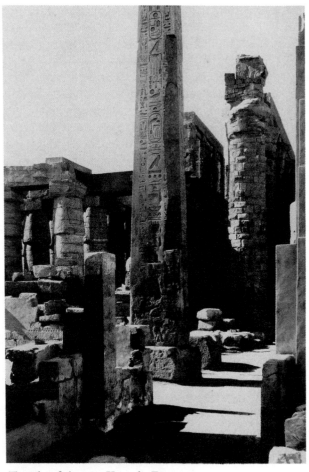

Temple of Amun. Karnak, Egypt.
19th Dynasty (1306–1186 B.C.).

nothing less than the introduction of writing: in the temple-pre-cinct a number of the individual forms may be called "even substi-tutes for books, since they announce the meanings not by their mode of configuration but by writings, hieroglyphics, engraved on their surface" (*A* 2:36). In the Egyptian temple-precinct one finds, according to Hegel, galleries in which the walls are completely cov-

ered with hieroglyphics: "They can be regarded like the pages of a book that by this spatial delimitation arouse in the mind and spirit, as do the sounds of a bell, astonishment, meditation, and thought" (*A* 2:37). The difference thus constituted is decisive. In the case of the Tower of Babel, of the Indian phallic columns, and of the Egyptian obelisks, the assembled or shaped stone of the work *is* itself the meaning that the work *expresses*. But once there is writing on the stone walls of the galleries within the Egyptian temple-precinct, the stone will no longer express the meaning by being that meaning, by actually embodying it by virtue of the architectural form given to the stone when it is shaped like a phallus or made to catch the god's sunrays. Now it will be, not the architecturally or quasi-sculpturally formed stone as such that will express the meaning, but rather what is written on the stone, the hieroglyphics. Even if there is not yet any trace of differentiation between such writing and the meaning it expresses, the linguistic-pictorial mode in which the hieroglyphics signify is fundamentally different from the way in which uninscribed stone signifies through its shape and form alone. Once writing comes to cover the stone, a mode of expression alien to architecture has come to invade the interior of the architectural work.

Writing remains, but with the pyramids there are new developments that serve to broach decisively the transition to classical architecture. One is the appearance of the straight line and, in general, of geometrical form. But more decisive is the link that such edifices have with a realm of the dead. Hegel maintains that it is only with the Egyptians that the opposition between the living and the dead is emphasized and that, correlatively, the spiritual begins to be separated from the nonspiritual. In honoring and preserving the remains of the dead, treasuring and respecting the body of the deceased, they preserve spiritual individuality against absorption into nature and dissolution into the universal flux. What emerges architecturally is the separation of the spiritual, inner meaning, in the guise of the respected and preserved body of the dead, from the shell (*Hülle*) that is placed around it as a purely architectural enclosure, the pyramid itself. The stones that were once shaped and assembled into edifices that *were* what they *meant* are now made into surfaces on which to write or into geometrical shapes suitable for enclosing—that is,

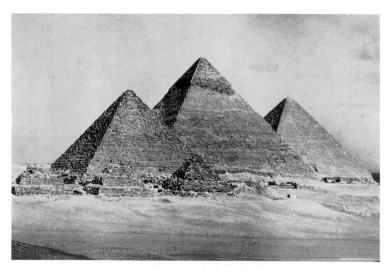

The Giza pyramids.
4th Dynasty (2723–2563 B.C.).

for marking a place for—the dead, who, preserved in their absence, will always have escaped the very presence that encloses them. Just as graves and tombs, says Hegel, become sacred places for those who live on. And indeed, hardly anything essential changes when, instead of a pyramid enclosing the body of a dead king, there is a simple gravestone marking the place where an unknown person, long since dead and gone, lies buried.

Architecture will have built principally with stone, not only in its symbolic beginning, but hardly less at the end, in the final form, romantic architecture. In the supreme achievement of romantic architecture, the Gothic cathedral, classical purposiveness is united with the independence of symbolic architecture. Here there is both the separation of means and purpose and the freedom of existing for itself. As always in Hegel's text, the opposites are submitted to the logic of *Aufhebung*, canceled as mere opposites yet held together as opposed moments within a supervenient unity. But in this case the logic is engraved not only in Hegel's text but also in the stone of the cathedral, in its lines, spaces, and configurations. In the

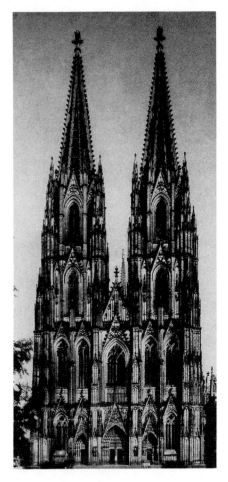

Cologne Cathedral.

Gothic cathedral the *Aufhebung* is displayed, there before one's very eyes, its sense manifest to a sensitive vision of the cathedral.

More thoroughly than the Greek temple, the cathedral forms an enclosure, a space of tranquility closed off from nature, indeed from everything mundane. Its enclosedness corresponds to the inwardness of the Christian religion: "Just as the Christian spirit draws

itself together into its inwardness, so the building becomes the place bounded on all sides for the assembly of the Christian community and its inward gathering" (*A* 2:72). The enclosedness of the cathedral both expresses the inwardness of Christian spirituality and provides a place for worship, for all the activities prescribed by that spirituality. Thus, in the cathedral there are no longer open entrance halls and colonnades left open to the world outside; rather, the columns are now moved inside the walls, set within a space closed off from nature and the outside world. From the interior of the cathedral the light of the sun is excluded or allowed only to glimmer dimly through the stained-glass windows: "For here it is a day other than the day of external nature that is to give light" (*A* 2:77). And yet, Christian worship is not only tranquil enclosedness but also elevation above the finite, and this elevation is what, beyond all purposiveness, determines the independent architectural character of the cathedral, which is built so as to express elevation toward the infinite, its spires soaring into the heavens. These are, then, the two moments that are brought together within the structure of the Gothic cathedral: "The impression, therefore, that art now has to produce is, on the one hand, in distinction from the cheerful openness of the Greek temple, the impression of this tranquility of mind [*Stille des Gemüts*], which, released from external nature and from the mundane in general, closes upon itself [*sich in sich zusammenschliesst*], and, on the other hand, the impression of majestic sublimity that aspires and soars beyond the limitations set by intellect [*das verständig Begrenzte*]" (*A* 2:73). Thus situating the architectural sublime within a moment of the beauty of the cathedral, Hegel draws the contrast with classical architecture: whereas the Greek temple is primarily set horizontally on the ground, the cathedral towers up from the ground, rising into the sky. Furthermore, it is no longer, as in the Greek temple, the supporting as such that provides the basic form of the building; for in the cathedral the walls have the appearance of striving upward, and the very difference between load and support comes to be canceled. The columns now become pillars: "But because the way the building strives upward precisely transforms load-bearing into the appearance [*Schein*] of free ascending, columns cannot occur here in the sense they have in

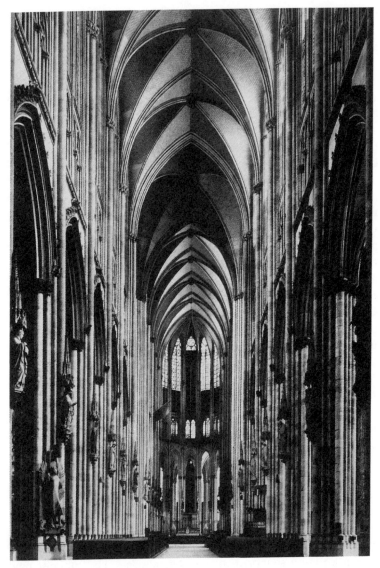

Interior of Cologne Cathedral.

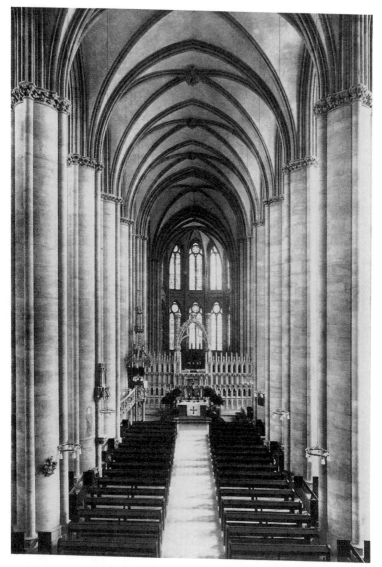

Interior of St. Elizabeth Church, Marburg.

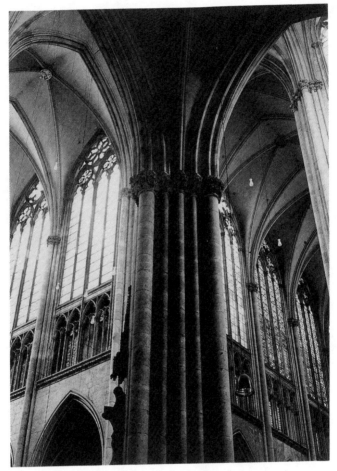

Pillars and Arches of the Cologne Cathedral.

classical architecture" (*A* 2:75f.). As they ascend, the pillars finally branch out and meet each other; and so, though the vault in fact rests on the pillars, their purpose of supporting the vault is not emphasized and is not as such presented in the architectural form. It is as though they were not supports at all: "If one enters the interior of a medieval cathedral, one is reminded less of the firmness and

mechanical purposiveness of the supporting pillars and of a vault resting on them than of the vaultings of a forest where in lines of trees the branches incline to one another and grow together" (*A* 2:75). In contrast to the column and the beam, which are clearly distinguished and which meet to form a right angle, the pillar rises gradually into the vault, and they appear as one and the same construction. The way in which the eye is thus led up the pillar to the vault, the architectural form designed thus to lead the worshipper's vision, corresponds to an aspect of Christian spirituality no less than does the enclosedness of the cathedral: "The pillars become thin and slender and rise so high that the eye cannot take in the whole form at a single glance but is driven to wander over it and to rise until it begins to find rest in the gently inclined vaulting of the arches that meet—just as the mind [*Gemüt*] in its worship, restless and troubled at first, rises above the soul of finitude and finds rest in God alone" (*A* 2:76).

In the Gothic cathedral the exterior is primarily determined from within, made to appear only as an enclosing of the interior. The cruciform shape, for instance, makes discernible from without the similar construction within, the distinction between transepts, nave, and chancel. Buttresses, too, mark from without the rows of pillars within, though in this regard the exterior begins to acquire a degree of independence, since the buttresses do not simply copy the form of the pillars within. This independence of the exterior is consummated in the way in which the interior's character as an enclosure is finally lost on the exterior and gives way there to the character of rising upward. Everything is given the appearance of free ascent: the high-mounting triangles that rise above the portals and windows, the slenderly pointed roof, the small peaked towers atop the buttresses, and especially the main towers themselves ("the most sublime summits"). And so: "just as in the interior the rows of pillars form a forest of trunks, branches, and vaults, so here on the exterior a forest of pinnacles extends into the heights" (*A* 2:81). Everywhere the stone is formed and decorated so as to give the appearance of rising into the sky. Little wonder, considering its heaviness, that the romantic architect comes, as Hegel says, "to refuse validity to the material, the massive, in its materiality and to inter-

Portal of Antwerp Cathedral.

rupt it everywhere, break it up, and deprive it of its appearance [*Schein*] of immediate coherence and independence" (*A* 2:82)—for instance, by way of elaborate decorations. Hegel says of Gothic architecture: "There is no other architecture that with such enormous and heavy masses of stone . . . preserved nonetheless so completely the character of lightness and grace" (*A* 2:82). Stone, deprived of its natural shining, is made to shine differently, to shine as if, renouncing its ancient heaviness, it now soared into the heavens. It is made so as to present spirit as best it can in an architectural work, even though, by the time of Gothic architecture, art will have been overtaken by its pastness. And the most perfect presentation possible in stone—or rather, with stone—will long since have been accomplished in classical sculpture.

Yet, within the Hegelian recollection sculpture, representing a higher form, follows architecture, succeeds it. What makes possible—indeed necessitates—the transition is the externality that proves inherent in architecture. When an architectural edifice, accordant with the very concept of such an edifice, comes to enclose a spiritual meaning, that meaning remains distinctly other; precisely in being enclosed, the meaning remains external to the external enclosure that architecture provides, remains outside the mere outside that architecture is limited to providing. The recollective transition to sculpture only makes explicit that spirit has proven to be outside the outside; it simply lets take shape the withdrawal from architecture's massive material, the withdrawal that the very logic of architecture will already have produced. Hegel says: "It is on the way of spirit's return into itself out of the massive and material that we encounter *sculpture*" (*A* 2:87), that *we* make the transition from architecture to sculpture—*we*, the recollective *we* capable of grasping the negativity of one stage as the taking shape of another, a *we* cognizant that negation is determinate.

Everything turns on the negativity, which drives the recollection on from architecture to sculpture, consigning architecture and eventually art as a whole to the past. In the case of architecture the negativity consists in the externality that makes the architectural

edifice something distinctly other than the spiritual meaning that it encloses and serves, that serves by enclosing. The end of architecture (in the double sense of *end*) lies in its enclosing a meaning that lies, nonetheless, outside it. Its end is to enclose as its meaning a meaning that does not belong to it, one that it can only enclose but not embody. Its end, the negativity that will drive it beyond itself, is to enclose as its meaning a meaning that, not belonging to it, is not its meaning—a meaning, therefore, that both is and is not its meaning. The negativity of this contradiction is what brings architecture to an end while still letting its spirit live on in and as sculpture.

Is this negativity assured? Does the externality that would separate architectural means from spiritual purpose remain intact once the Hegelian recollection is submitted to critical scrutiny? Does the purity, the utter distinctness, of the separation between the outside that encloses and the inside that lies outside the outside remain uncontaminated even when the Hegelian recollection is, from a distance, repeated, itself re-collected across that distance? Or is there a possibility of bringing architecture back, of calling it back to life, even though the Hegelian recollection has declared it long since dead and gone? Is there a possibility of bringing it back in its bearing on the living, not as a mere epigone but as something before which, to modify Hegel's own phrase, we bow our knees again? Could the very possibility of calling architecture back to life derive from the way in which the Hegelian recollection has declared it dead and through this declaration produced something like a semblance of its death?

Almost as in the theatre, where everything, including death, is a semblance, a shining produced through speech and the enactment that accompanies it. The semblance may even be compounded so that within the usual theatrical semblance there is enacted, represented, another semblance, for example, a semblance of death, of the absolutely nonpresentable as such. As in the play—Shakespeare's *Much Ado about Nothing*—that, as its title says unmistakably, is almost nothing but a series of plays within the play, semblances enacted within the semblance: a heroine named Hero, wooed by one pretending to be another, wooed for that other (Claudio), while at the same masquerade party another couple, Beatrice and Benedick,

speak from behind their masks as if they did not recognize one another, hence speaking about one another as if to an other; scenes are staged for each of them by others, whose feigned conversations serve in both cases to present semblances that evoke, in each, love for the other, hence a love between Beatrice and Benedick that, evoked by semblance, remains itself curiously semblant until the final scene of the play. But there is also semblance of semblance when, in the wedding scene, after Hero, disgraced by the words of Claudio, has fallen into a swoon that looks like death, after Claudio and his companions have left the scene and Hero has awakened from her semblance of death, the Friar, who was to have married Claudio and Hero and will in fact marry them the following day, says:

> So will it fare with Claudio.
> When he shall hear she died upon his words,
> Th' idea of her life shall sweetly creep
> Into his study of imagination,
> And every lovely organ of her life
> Shall come appareled in more precious habit,
> More moving, delicate, and full of life,
> Into the eye and prospect of his soul
> Than when she lived indeed.[12]

Such power of semblance is attested, not only by drama, the very element of which is *Schein*, but equally by the theoretical-recollective discourse of the *Aesthetics*, echoing logic itself: "*Shining* itself is essential to *essence*" (*A* 1:19). To say nothing of the power of imagination (*Einbildungskraft*), which Hegel once called "nothing but reason itself."[13]

What of living architecture? What of architecture's bearing on the living? What of its bearing when, for example, by building a

12. *Much Ado about Nothing*, act 4, sc. 1, lines 221–229.
13. *Glauben und Wissen*, in *Jenaer Kritische Schriften*, ed. Hartmut Buchner and Otto Pöggeler, vol. 4 of *Gesammelte Werke* (Hamburg: Felix Meiner, 1968), 329. *Glauben und Wissen* first appeared in 1802 in the *Kritisches Journal der Philosophie*, edited by Hegel and Schelling. Hegel's identification of imagination with reason echoes what Schelling had written two years earlier in his *System des transzendentalen Idealismus* (Hamburg: Felix Meiner, 1957), 227. Hegel does not make the identification without qualifications, most notably the one that follows

house, a human habitation—a kind of edifice repeatedly marginalized in Hegel's account—it provides shelter for the living? For sheltering is not a mere means external to those whom the house shelters but rather bears on the very constitution of their comportment to what surrounds them, to the elements as delimiting the very space of natural existence. Those who are sheltered are not encapsulated purposes, in which there would be only meaning turning into meaning; rather, they are extended into the space bounded and shaped by the elements, comporting themselves always to this space in a way essentially linked to sheltering and its possibilities. Thus, the architecture that builds, for example, a simple stone house as shelter from mountain storms will not have provided a mere means external to a purpose quite distinct from the enclosure; it will not merely have provided an enclosure for living human beings as if their basic comportment could remain essentially independent of the sheltering brought by the enclosure. However simple such architecture may seem, in contrast to that which builds temples or cathedrals or, today, skyscrapers, what it builds does not fall away from the living into an externality that would have the effect of inscribing within the building a negativity, one that would consign it irrecoverably to the past, like death itself, saving for the future only its resurrected spirit.

I have suggested that, from such distance, much the same might be said of the temple. If the spacing belongs essentially to the epiphany of the god, then the revelation cannot be simply something other, for which still another art, sculpture, would have to provide; it cannot be a meaning simply and distinctly outside the very temple that encloses it. There can be no such pure externality and thus no

immediately in his text: "only reason as appearing in the sphere of empirical consciousness." The entire discussion has an explicit orientation to Kant's discussions of the productive imagination and of its relation to thought and to intuition. By the time of the *Encyclopedia* Hegel has integrated the concept of imagination into a systematic context that has the effect of limiting its scope and power as compared with that accorded it in *Glauben und Wissen*. See *Enzyklopädie der philosophischen Wissenschaften im Grundriss (1827)*, ed. Wolfgang Bonsiepen and Hans-Christian Lucas, vol. 19 of *Gesammelte Werke* (Hamburg: Felix Meiner, 1989), 333–339 (§§455–460). I have discussed these sections in *Spacings—of Reason and Imagination,* chap. 5.

consignment of classical architecture—and, hence, of architecture as such, to the very concept of which classical architecture corresponds—to the past. Even if, from this distance, one will want to say, in another sense, that the Greek temple is decisively past: not because its spirit has been released from its heavy matter, freed for the future, but because its spirit has vanished and there is no longer an epiphany of the god. Now the pastness would no longer be merely the other side of an appropriation to religion.

The temple could indeed provide an example in reference to which one might reopen the question of the concept of architecture as such, putting into question the bond of this concept to that of enclosure: first of all, by rethinking enclosure as a mode of spacing, of shaping the space within which something like the epiphany of a god could occur; but then, also by considering whether it is only a matter of the enclosing shape into which the stone is configured or whether the essential character of the open interior of the temple is perhaps also determined by other features of the stone, independently of their relevance to the capacity of the stone to enclose, such features (here one would need eventually to undermine such language of quality) as its hardness, the texture of its surface, its heaviness.

In the case of the Gothic cathedral the pure externality of means and purpose, of enclosure and meaning, is compromised by the peculiarly mimetic character of the cathedral. Hegel's own descriptions avoid explicit reference to mimesis, no doubt because of the severe critique that, near the beginning of the *Aesthetics*, Hegel brings against a very narrowly conceived sense of mimesis (see *A* 1:51–55)—even though one could indeed read the entire *Aesthetics* as an attempt, over against this inferior kind of mimesis (as mere copying), to reestablish a genuine sense of mimesis (ultimately as *Darstellung*). In any case, Hegel's own descriptions of the Gothic cathedral outline the mimetic character without calling it by name. The purposiveness of the cathedral lies in its providing a place for worship, which, essentially determined by the inwardness of Christian spirituality, is such as to require that its place be fully enclosed, in contrast to the open enclosure of the Greek temple. The distinctive enclosedness of the cathedral thus expresses as its meaning the

inwardness at the heart of Christian worship and Christian spirituality as such. In this respect the cathedral expresses a meaning, serves a purpose that it cannot itself embody, that it cannot sensibly present as such in its masses of heavy matter shaped and bound together according to the laws of gravity. And yet, in its enclosedness the cathedral does not express Christian inwardness merely by signifying it across a distance that would effect a pure separation between signifier and signified, between expression and expressed. Rather, the enclosedness of the cathedral expresses the inwardness of Christian spirituality *by mimesis*, by imitating in its various features (which Hegel discusses in detail) spirit's turn inward away from everything natural and mundane. But in mimesis there is no pure externality between expression and meaning. It is the same on both sides: not only in the cathedral's independent character, in its elevation toward the infinite, which it both *means* and *imitates*, meaning it by imitating it, but also in its purposiveness, its providing an enclosure for worship. On both sides the cathedral resists the negativity that would free its spirit from the heaviness of stone, resists it precisely by imitating spirit in stone. What the cathedral provides is not just an enclosure but an enclosure shaped to, formed in the image of, what it encloses, an enclosure also shaped into, blending into, the expression—equally mimetic—of the other meaning displayed by the Gothic cathedral, elevation into the infinite, ascent.

And yet, in the way that the Gothic cathedral resists submitting to the sheer negativity that Hegel finds invading classical architecture, one might see taking shape precisely the *Aufhebung* that will lead to sculpture. For with the transition to sculpture spirit will be freed, as it were, from those assemblages of stone that enclosed it without being able, it seems, to embody it. Spirit will be released from the enclosures, like a bird freed from its cage and allowed again to soar into the sky. To be sure, even sculpture will still encase spirit in matter, but now—at least in its classical perfection, where it becomes the very perfection of the classical as such—it will set spirit only into pure, white marble, which it will shape without the slightest regard for weight or natural conditions, giving to spirit, as Hegel says, "a corporeal shape appropriate to the very concept of spirit and its individuality" (*A* 2:88). It will be as if the stone—pure, white

marble—had completely lost its heaviness, as if it had been given wings.

Just as the stone of the Gothic cathedral is relieved of its heaviness, its materiality, and made as if to ascend. In the transition it would be only a matter of a shell falling away, the architectural shell that would have enclosed sculpture, as the temple enclosed the statue of the god, but that would finally fall away so as to let the living kernel itself come to the light of day. In the Gothic cathedral, in the aging shell, we will already have caught a glimpse of the shape of what lies within. In the Gothic cathedral we will already have seen the *Aufhebung* taking shape before our very eyes, in those lines, spaces, and configurations that relieve the stone of its ancient heaviness and make it soar freely in its ascent. We—a recollective *we*, who can still, as Hegel in fact did,[14] visit a Gothic cathedral and behold it in its sublime beauty.

Or, today, in its strangeness, its uncanny beauty, its *Unheimlichkeit*. In this case we—no longer the *we* of Hegel's text—would be driven to invent for what we beheld a logic stranger than that of *Aufhebung*. The primary schema would no longer involve relieving stone of its heaviness in preparation for its reception (as pure, white

14. During the Berlin period Hegel took three extensive trips on which he visited numerous cathedrals. The first trip, to Belgium and the Netherlands in 1822, offered him especially rich possibilities. In Marburg he saw "St. Elizabeth Church in pure Gothic style" (*Briefe von und an Hegel*, ed. J. Hoffmeister [Hamburg: Felix Meiner Verlag, 1953], 2:348 [#434]). In Cologne he visited the cathedral (and even attended mass there) and wrote to his wife: "I searched out the cathedral right away. The majesty and gracefulness of it, i.e., of what exists of it, the slender proportions, the attenuation in them, which is not so much a rising as an upward flight [*Hinauffliegen*], are worth seeing and are fully worthy of admiration as the conception of a single man and the enterprise of a city. In the cathedral one vividly beholds in every sense a different condition, a different human world, as well as a different time. It is not a matter here of utility, enjoyment, pleasure, or satisfied need, but of a spacious wandering about in high, independent halls [*für sich bestehenden Hallen*], which are, as it were, indifferent whether men use them for whatever purpose. . . . [It] stands there for itself and is there regardless of whether men creep around down below or not. It does not matter to it at all. What it is, it is for itself. . . . All this—standing and walking around in it—simply disappears in it" (*Briefe* 2:353 [#436]; cf. 2:355 [#437]). Hegel continued through Aachen, visiting the cathedral there, then went on to Ghent, where he saw "the beautiful cathedral" (*Briefe* 2:358 [#438]), and then to

marble) of the shape of spirit. Rather, the schema would now be one of repression, of "something repressed that recurs."[15] It would be a matter of repression and return, not as isolated events in some psyche, but as constituting a schema that, like Hegel's categories, belongs to a logic, even if a strange one. According to this schema something familiar returns as something uncanny: one and the same thing, now *heimisch* (native, homelike, and, so, familiar), now *unheimlich*, opposites assembled across the interval constituted by the operation of repression and return. It is the weight of stone that will have been repressed, along with the supporting and permanence that go with it. They will have returned on the wings of spirit, in the uncanny ascent by which stone comes to imitate elevation into the infinite, which promises a weight, support, permanence that are not to be found on earth.

Only the slightest phantasy would be needed in order to evoke the semblance of another return, in order to see the Gothic cathedral as a return of the Tower of Babel, as a return *to* the Tower of Babel, architecture thus enclosing itself in an uncanny circle, a representation of recurrent life, of a rebirth that would not be only of spirit. A semblance, no doubt: for the Tower of Babel is not some-

Antwerp, whose "world-famous cathedral" he described, again in a letter to his wife, in this way: "In its nave, as in the unfinished cathedral in Cologne, are three rows of pillars on each side. How spaciously and freely one wanders about in it!" (*Briefe* 2:359 [#438]). Two days later he wrote, from The Hague: "Thus in the end it was a matter of churches. The churches in Ghent and Antwerp, as I said, must be seen if one wants to see sublime, rich Catholic churches—large, broad, Gothic, majestic. Stained-glass windows—the most splendid ones I have ever seen are in Brussels" (*Briefe* 2:359 [#438]). Hegel's second trip, to Vienna in 1824, was more fruitful musically than architecturally, though, in a letter to his wife, he does mention being in St. Stephen's church (*Briefe* 3:55 [#479]). His third trip, to Paris in 1827, gave him the opportunity to visit churches in Trier (including the basilica of Constantine), the cathedral in Metz, and the famous cathedrals (including Notre Dame) in Paris ("this capital of the civilized world") (*Briefe* 3:182 [#557]; 3:183 [#558]; 3:183 [#559]; 3:186 [#560]). On his return voyage from Paris to Berlin he again saw the cathedral in Aachen and paid "another visit to the sublime cathedral" in Cologne (*Briefe* 3:202 [#566]).

15. Sigmund Freud, "Das Unheimliche," in *Gesammelte Werke* (Frankfurt a.M.: S. Fischer Verlag, 1947), 12:254. This is a logic that to Freud could only seem to violate logic, however much its strange operation may have been confirmed by psychoanalysis.

thing that will ever have been familiar (even if then repressed), that will have been indigenous, belonging to the home surroundings; unlike the Gothic cathedral, which one can visit and behold, the Tower of Babel will be known of only from reading the biblical account and perhaps from seeing some highly imaginative representations. And yet, precisely because it is so indefinite, defined by little more than the few verses that Genesis devotes to it, it can serve as an example in which to gather what one would say of the beginning of architecture, say on the basis of a certain elemental familiarity. Is it not indeed largely as such a gathering point that the Tower of Babel functions in Hegel's text—to such an extent even that he omits some major elements of the biblical account?

Even before phantasy intervenes to project that point and prepare the return, the massive correspondences are evident. Both edifices lay claim to a certain universality, a commonality: the cathedral in housing the universal religion and in symbolizing the infinite, the Tower of Babel in symbolizing the community, the unification of peoples. Most remarkably, Hegel forgoes mentioning something in this regard that is quite prominent in the biblical account: that the community of peoples that would be symbolized by the Tower is linked to a community of language, that at that time "the whole earth had one language,"[16] and that the peoples' forsaking the Tower and then being dispersed resulted from Yahweh's mixing up their language, introducing linguistic diversity so that they no longer shared a common understanding. All of this Hegel leaves unsaid, as if the claim to universality were not always exposed to the threat posed by linguistic diversity, as if it were not for the most part accompanied by an institutional legitimation of the universality of *a* language, whether it be that unnameable tongue spoken by the ancient Babylonians or medieval Latin. Or German. Or English.

But even granted this omission in Hegel's account, there is still no denying the correspondences between the Gothic cathedral and the Tower of Babel: not only do both lay claim to universality, but

16. Gen. 11:1. In citing from the Genesis account I use the translation given with notes and commentary by Gordon J. Wenhem, *Word Biblical Commentary* (Waco, Texas: Word Books, 1987), 1:232ff.

also, in the very way their heavy matter is shaped, assembled, perhaps even marked, both are essentially ascensional, both of them tower up into the heavens and have their universal meaning precisely in so ascending.

There is one other element in the biblical account that is lacking in what Hegel says of the Tower of Babel, indeed not just lacking but replaced by something else (that it itself replaced), a misrepresentation, then, an error, as it were.[17] Whereas Hegel refers to the assembled blocks of *stone*, the masses of stone put together (*die zusammengefügte Steinmasse*) to construct the Tower, the biblical account reads: "They said to each other, 'come, let us make bricks and bake them thoroughly.' So they had bricks for stone and asphalt for mortar."[18] Lacking stone in the Tigris-Euphrates valley (the biblical "plain of Shinar"), the Babylonian architects substituted bricks that they themselves had made, constructing the Tower from these rather than from masses of stone taken directly from nature. If in the Gothic cathedral stone is relieved even (and especially) of its native heaviness, if it is deprived of its very appearance of immediate

17. In his *Lectures on the Philosophy of World History*, which stems from the same period as the *Aesthetics*, Hegel also mentions the Tower of Babel. But here he recognizes that according to the biblical account it was made of bricks. Recounting the description given by a contemporaneous observer who had found what he thought were remnants of the Tower, Hegel writes: "On an elevation he believed he had discovered the remains of the old Tower of Babel; he supposed that he had found traces of the numerous roads that wound around the Tower. . . . Furthermore, there are many hills with remains of old structures. The bricks [*Backsteine*] correspond to the description in the biblical account of the building of the Tower; a vast plain is covered by an innumerable multitude of such bricks" (*Vorlesungen über die Philosophie der Weltgeschichte*, vol. 2: *Die orientalische Welt*, ed. Georg Lasson [Hamburg: Felix Meiner Verlag, 1968], 434). One should not overlook the fact that the construction of the German word *Backstein* could legitimate taking brick to be a kind of stone, so that the misrepresentation found in the *Aesthetics* would have consisted only in the substitution of the genus for the species—that is, Hegel would simply have spoken metaphorically, according to the most classical concept of metaphor (see Aristotle, *Poetics* 1457b7–9). Nevertheless, the crucial difference would remain (or would have been covered up by the metaphor): bricks are man-made, whereas stone is taken directly from nature.

18. Gen. 11:3. See *The Interpreter's Bible* (New York/Nashville: Abingdon-Cokesbury Press, 1952), 1:564; and Wenham, *Word Biblical Commentary*, 1:239.

coherence and independence, covered with decorations that mask its character as stone, that make it appear as if it were not stone but something made by the architects themselves, the result will not be unlike that produced when the Babylonians had recourse to man-made bricks in place of natural stone. Another correspondence linking the beginning and the end of architecture.

It would not be difficult, then, to imagine the stone expanding so as to fill in the empty enclosures, the cathedral metamorphizing into a solid tower like those built in the beginning of architecture.

So then, the slightest phantasy will suffice to see architecture turned into this circle, the return of the Tower of Babel intervening at just that point where spirit would otherwise have been prepared to abandon architecture to its pastness, leaving it behind as if for dead. What is more difficult, since it pertains to the earth itself, is to picture to oneself any such communication between the respective sites, one of them north of the Alps, the other in the Tigris-Euphrates valley, quite outside the European homeland to which spirit is to return. Yet, both the cathedral and the Tower soar freely above the earth.

Imagine, then, a theatre of stone. Imagine architecture, its course from symbolic through classical to romantic, turned into a circle. On one side of the circle stands the Tower of Babel, in which natural stone is replaced by man-made bricks. On the other side stands the Gothic cathedral, made to appear as if it were not of stone. As stone thus disappears at the periphery of the circle, it will be as if the curtain were opened revealing on stage, at the center, the sole work in which stone decisively remains, the Greek temple.

4

TEMPLE OF EARTH

FLIGHT IS ELEMENTAL.
For example, flight of stone. Taken from nature, shaped and assembled into the Gothic cathedral, the form and decoration orienting everything heavenward, stone is made to forswear its ancient heaviness, made to ascend as if it were sheer lightness and grace. An uncanny flight. Now doubly so, even if one responds only with silence to the madman's question: "What after all are these churches now if they are not the graves and tombs of God?"[1] It is as if what once returned on the wings of spirit now came back only to haunt the graves marked and sealed by the stones of the great cathedrals. It is as if the heaviness of stone, the weight of spirit, finally returned in the ghastly form of a mere shade, the monstrosity of a shadow: "After Buddha was dead, his shadow was still shown for centuries in a cave—a monstrous, ghastly shadow."[2] The uncanniness—or a *Stimmung* akin to it—remains even if one refuses this semblance, taking to heart instead the words of Hölderlin:

> But, my friend, we come too late. The gods do indeed live,
> But over our heads, up there in another world.
> Endlessly there they act and seem to care little,
> Whether we live, so much do the heavenly ones spare us.[3]

Then it would be as if what once returned—or first arrived—on the

1. Friedrich Nietzsche, *Die fröhliche Wissenschaft*, in vol. V 2 of *Werke: Kritische Gesamtausgabe*, ed. Giorgio Colli and Mazzino Montinari (Berlin: Walter de Gruyter, 1973), 160 (§125).
2. Ibid., 145 (§108).
3. Friedrich Hölderlin, "Brot und Wein," in *Sämtliche Werke und Briefe*, ed. Günther Mieth (Munich: Carl Hanser Verlag, 1970), 1:313.

wings of spirit—or in the ecstasy of the wine-god—had now—long since—fled, taken flight. *Entflohene Götter.*

Flight, then, also into the past. As art has flown into the past, its course charted retrospectively in Hegel's *Aesthetics*, in the recollection of art as consigned to its pastness. As architecture took flight into the past at the very moment that it came fully to presence, in the Greek temple, in its degradation and appropriation by classical sculpture. But now, it seems, everything classical, everything originarily Greek, is dead and gone, even if its monstrous ghosts return like a Golem to devastate the earth. The question is whether something else of that past can be brought back, whether what is properly, originarily Greek (in Heidegger's phrases, *das anfänglich Griechische, das Eigene der griechischen Welt*) can be made to return, even to come toward us from out of a future. Also whether, flying southward over the Alps, returning to that ancient land, one could sense there the presence of the originary. Retracing, but now southward, the course of the eagle that once flew over the snow-covered peaks of Parnassus, high above the votive hills of Italy, and then, exultant, winged on over the Alps to the lands of the north.[4]

Flight, then, also as of a bird. Zarathustra assumes the guise of a bird in order to sing of flight, voicing in his song the utmost hostility to the spirit of gravity, of heaviness. Here is how the song begins: "He who will one day teach men to fly will have moved all boundary stones; the boundary stones themselves will fly up into the air before him, and he will rebaptize the earth—'the light one' ['*die Leichte*']."[5] This flight, too, is thus a flight of stone. But now, pictured in the phantasy of song, it does not imitate and emulate a flight of spirit, for now spirit has proven only a burden weighing man down and impeding his flight. Nietzsche's schema is one of inversion: rather than being elevated toward spirit in such a way as to prepare the *Aufhebung* that submits it to spirit, stone replaces spirit, exchanges places with spirit, their order being reversed, its

4. See Hölderlin, "Germanien," in *Sämtliche Werke und Briefe*, 1:362.

5. Nietzsche, *Also Sprach Zarathustra*, vol. VI 1 of *Werke: Kritische Gesamtausgabe*, ed. Giorgio Colli and Mazzino Montinari (Berlin: Walter de Gruyter, 1968), 238. The entire section is entitled "Vom Geist der Schwere."

terms inverted. Now it is stone, indeed the earth itself, that is light and spirit that is heavy, so that in learning to fly men will no longer soar beyond the earth but will have hearkened to Zarathustra's exhortation to remain true to it. Or rather, in soaring beyond the earth men will be brought back to the earth, learning to be true to it and to forsake all higher worlds, all so-called true worlds. This double directionality as well as that of the boundary stones, dislocated both on the earth and from the earth, mirrors and serves thus to indicate the double move that the inversion broaches, the doubleness that prevents its being simply an inversion, that makes it begin to twist against the very opposition inverted, to destabilize the opposition as such, thereby also working against the founding opposition, that between intelligible and sensible. To this extent the song of the bird is a prelude to the story that Nietzsche will eventually tell of how the true world finally became a fable. In the wake of the demand that this story imposes for a new interpretation of the sensible, the allegorizing of stone by which it is made to give public notice (ἀγορεύω) of something other (ἄλλο), something of a different order, can only appear as a deformation. Once the sense of sense is made questionable, once the opening within what this single word would say is exposed to the abyss, once all stabilization by way of flight to a true world beyond is prohibited, one will be brought back to stone itself, to its manifestation, and to its power in its manifestation to let shine forth the very character of manifestation as such.

In the spring of 1962 Heidegger visited Greece for the first time. For some years he had been encouraged to make such a trip, both by his wife, who was to accompany him, and by friends such as Erhart Kästner. But he had hesitated, and, in fact, two years before finally making the trip, he had canceled his plans to travel to Greece with the Kästners.[6] Yet, once he had made the trip, he had little

6. In a letter to Kästner dated 21 February 1960, Heidegger writes: "All week I have pondered back and forth whether I should still venture the trip to Greece, which my wife planned so nicely for me years ago" (Martin Heidegger–Erhart Kästner, *Briefwechsel*, ed. Heinrich W. Petzet [Frankfurt a.M.: Insel Verlag, 1986], 43 [#12]).

hesitation about subsequent trips to Greece. His second visit involved an extended stay on Aegina; his third trip, in 1967, was to Athens to present his lecture "The Origin of Art and the Destination of Thinking."

Heidegger's hesitation about his initial trip to Greece was deeply rooted: what concerned him was, not the practical difficulty of such a voyage, but rather the decisiveness that it assumed in view of the engagement of his thinking with the Greeks. Several years earlier he had written to Kästner: "Greece is still always the dream, and every new advance of thinking lives in it."[7] In the notebook that he kept during the visit, he confesses that his long hesitation stems from fear of disappointment.[8] He is uncertain about modern Greece, uncertain whether the Greece of today might not prevent the Greece of antiquity and what was proper to it from coming to light. His most serious doubt, however, concerns the conception of Greece as, in the words of Hölderlin, the land of the gods who have flown (*das Land der entflohenen Götter*); his concern is that this conception might prove to be merely invented, a phantasy testifying as such against his own *Denkweg*, showing it to be an *Irrweg*.

Heidegger's doubts persist as the ship, sailing from Venice through the Adriatic, comes within sight of Greece. After two nights at sea the ship arrives early in the morning at the island of Corfu. But what he had expected, what he had long awaited, does not appear. Is this really Greece, he wonders, or only the periphery? He confesses his concern that the notions he has brought along, preconceived, may be exaggerated and misleading. Everything he sees resembles an Italian landscape, and his reflections trail off in a series of questions about Goethe's experiencing the nearness of Greece in Sicily: the question is especially whether Goethe did not remain tied to a Roman-Italian view of Greece seen in the light of modern humanism. Though Heidegger leaves Hölderlin unnamed in this connection, the contrast is implicit: though Hölderlin never traveled beyond the south of France, it is he who gained access to

7. Ibid., 34 (#7). The letter is dated 16 July 1957.
8. Heidegger presented the notebook to his wife on the occasion of her seventieth birthday. It has now been published as *Aufenthalte* (Frankfurt a.M.: Vittorio Klostermann, 1989). Hereafter *Auf*.

originary Greece. A few months after the first trip to Greece Heidegger will write to Kästner: "Often it seems to me as if the whole of Greece is like a single one of its islands. There are no bridges to it. It is an origin [*Anfang*], and Hölderlin has saved what is originary about it [*sein Anfängliches*]."[9]

Doubt only increases as the ship sails on to Ithaca, doubt as to whether even the legendary home of Odysseus will offer an encounter with what is originarily Greek (*das anfängliche Griechische*). Going ashore to visit the small churches, to see their Byzantine icons, to attend a warm reception by the local people—all of this leaves Heidegger's doubts totally unabated: there is no sign of the Greece he is seeking.

Sailing on to the Peloponnesus, going by bus to Olympia, Heidegger cannot but ponder how it was that in such a region, not unlike many seen in Italy, the Greeks came to establish the place of the great festival in honor of the highest gods. He visits the ruins of the great temples dedicated to Hera and to Zeus, now little more than base-walls with pieces of columns lying about; he notes that the columns, even in ruin, still preserve something of their upward, supportive thrust. He visits the stadium but finds little trace of the beauty of the festival, of the great contests once held there. His visit to the museum at Olympia is more fruitful: seeing the Hercules Metope, its sculptured figures showing Hercules, aided by Athena, taking Atlas' load upon his shoulders, Heidegger is struck by the unison of this sculpture with the others in Olympia and senses in all of them something of the same style that was realized in song in the powerful poetic language of Aeschylus' tragedies. Heidegger asks, finally, whether Olympia offers the insight he has sought into what is proper to the Greek world. His answer: yes and no. Something is indeed granted by the sculptures, something evocative of the poetry of Aeschylus that he has brought in memory to the encounter. And yet, the sculptures are displaced, set up in a museum, and the region itself fails to set free, to manifest, the properly Greek land, sea, and sky.

Sailing through the Bay overnight, the ship arrives in the morning at Corinth, where Heidegger and his companions disembark in

9. Heidegger-Kästner, *Briefwechsel*, 51 (#17).

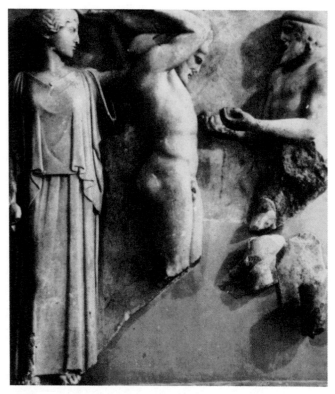

Metope: Athena, Hercules, Atlas.
Olympia Museum.

order to visit Mycenae, with its pre-Greek ruins, then Argos, then
Nemea. This other place of the Greek games resounds more deci-
sively than did Olympia: the whole region around Nemea seems like
a stadium uniquely inviting for festive games. Heidegger is drawn
especially to the ruins of the temple of Zeus, to the three columns
that remain standing: "In the breadth of the landscape like three
strings of an invisible lyre, on which perhaps, inaudibly to mortals,
the winds play songs of mourning—echoes [*Nachklänge*] of the
flight of the gods" (*Auf.* 12). Here, then, is perhaps a trace, a site
where, though it remains invisible and inaudible, one may sense

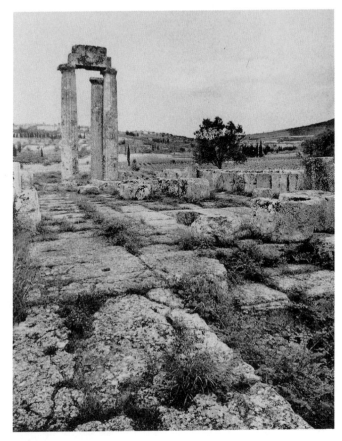

Temple of Zeus. Nemea.

something of the properly Greek, something of its withdrawal from the modern landscape, a withdrawal that leaves behind a trace rather than sheer absence, that leaves a trace inscribed in the ruins, in the three columns that can still be seen standing against the Greek sky. The one other site that Heidegger visits on the Peloponnesus also seems to resound with such withdrawal, and there, in the ancient theatre at Epidauros, Heidegger responds in words taken from Hölderlin:

Why are they silent too, the ancient sacred theatres?[10]

But still the question remains: Where is one to find what is most
proper (*das Eigenste*) to Greece? Where is one even to seek it?

One wonders. Is it to be sought and found by traveling at all? Is
it to be discovered only by rethinking what is said in the texts left
by the Greeks, or can one find in what remains present in the place
still called Greece something that, in its presence, will fulfill what
one will previously only have thought, intended? Is such a fulfilling
site to be found in the same way that an object, perhaps something
one has misplaced, is found? Is what one would find at such a site
merely a presence capable of fulfilling the thought that one would
have brought on one's travels to Greece? Is it not rather the trace
of withdrawal inscribed in a presence—is this not what could, if
anything, bring fulfillment, like the echo sounding inaudibly from
the three remaining columns of the temple of Zeus, like the silence
of the great theatre at Epidauros? Even in this case would it be a
matter only—if at all—of fulfillment, of a confirming intuition fill-
ing out, giving intuitive content to, what had only been thought,
emptily intended? Or could what one comes to sense in Greece have
a more differentiating impact, perhaps even interrupting and dis-
placing what one would have thought (as) the properly Greek? Is
there a reason for one like Heidegger to travel to Greece? Can such
travel, at best, only provide, through the discovery of concrete ex-
emplification, a confirmation for what one will already essentially,
properly, have thought?

As the ship sails toward Crete, Heidegger knows that he is on a
detour through the ruins of a very foreign, pre-Greek world. Sailing
on to Rhodes and then past the smaller islands of the Dodecanese

10. *Auf.* 13. The line comes from the sixth strophe of Hölderlin's "Brot und
Wein." Today this silence is literally broken, ancient dramas being performed
regularly in the theatre at Epidauros. In this connection one could pose even
more pointedly the question of the relation between the ancient texts and a cer-
tain fulfillment, in this case performance, possible only in what remains in
Greece.

evokes only the reflection that the *Auseinandersetzung* with the Asiatic was "a fruitful necessity for the Greeks" (*Auf.* 16).

It is the sea that gives the first hint of something different: "As night was swiftly falling and, standing for a long time at the railing, we looked into the deep-blue, sometimes effervescent water," there was a more intense expectation (though not without reservation) of encountering the properly Greek; or, as Heidegger puts it—curiously conflating the difference between thinking and encountering—the expectation of "finding an answer to the constantly summoning question of the proper [*das Eigene*] of Greek Dasein and of its world." Heidegger asks, retrospectively: "Was this dark water a sign, in advance, of the self-concealing answer that was to come?" (*Auf.* 18).

Sailing on across the dark waters, the ship arrives in the morning at Delos. The island is hardly inhabited and its vegetation quite sparse. But, almost as if in place of man and nature, it has an abundance of temple ruins, and Heidegger's responsiveness to the island is almost immediate. It is, most remarkably, a response to the desolation of the place: "In comparison with everything seen thus far on the trip, the island appeared at first glance desolate and abandoned. . . . Then, forthwith there emanated from it a unique claim perceptible nowhere else thus far" (*Auf.* 18). Everything on the island bespeaks the great beginning that once took place—that is, through all the things of the desolate, abandoned island, the Greek origin speaks, not as something present in or behind those things, but as withdrawn from presence, as essentially, properly veiled, *das Verhüllte eines gewesenen grossen Anfangs.*

Heidegger muses on the meaning of the name of the island: Δῆλος means the manifest (*die Offenbare*), which gathers everything into the open (*in ihr Offenes*); it means that which shines (*die Scheinende*), which through its shining shelters everything in a presence. Desolate and abandoned as it may be, lacking in vegetation and inhabitants, the island is nonetheless, at least in name, akin to the beautiful. But not only in name, not only in a meaning, which, even if borne by the Greek name, has been brought back from beyond the Alps. Now, in Delos, that meaning is no longer just in-

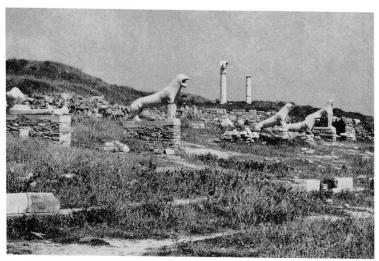

Processional Way. Delos.

tended but is encountered in the stone of the island itself: "With each of the steps that led us over the deformed elemental stone [*über verwachsenes Urgestein*] and over pieces of ruins, up, in an ever stronger wind, toward the cleft peak of Kynthos, which rose steeply from the center of the island, the meaning of the name of the island became more significant and what it meant became more existent [*seiender*]" (*Auf.* 19). What is meant in the name, namely, the manifest, is itself manifest as one climbs over the elemental stone and over the stone that remains of ancient temples and other sacred edifices. The manifest, the open, the shining are no longer mere names, mere meanings—not for one who responsively traverses the open space of the stony mountain slopes, bathed in the blazing light of the Greek sun and its reflection from the elemental stone of the mountain itself, one who from that height gazes upon the surrounding country, glistening under the brilliance of the light, and upon the things of the countryside made manifest in their presence by that shining. Heidegger's friend Heinrich Petzet reports that on those few occasions when Heidegger later spoke of what he had

found especially striking on his travels in Greece, he often remained completely silent about all the particulars and mentioned only the Greek light.[11]

But in the notebook it is not only of the light that Heidegger writes, not only of the manifest that becomes itself manifest in the presence of Delos. On the contrary, Heidegger passes abruptly from manifestness, overtness, shining to concealing (*Verbergen*) and sheltering (*Bergen*). The transition could perhaps not be otherwise than abrupt in the present context, considering the decisiveness attributed to it in other texts, that it is, most notably, the very movement at the limit of metaphysics, across the expanse where metaphysics would be overcome and another beginning broached through the remembrance of the Greek beginning.[12]

The abruptness of the transition belongs, then, to the very matter itself, and in the most rigorous sense there is no transition at all but only—and precisely in the most developed and articulated discourse—a leap. And yet, perhaps elsewhere it is different. Perhaps in Greece itself, in Delos, as one makes one's way up the mountain, stepping across stone deposited on the slopes both by nature and by an ancient art ravaged by time—perhaps there under the brilliance of the Greek sun one senses a connection that might otherwise remain sheltered at its Greek site, that is, concealed from all who fail to return to the presence of that site. In the Greek light the stone shines so brilliantly, not only because the light is so intense, but also because stone withholds all but its surface from the light, reflecting it rather than translucently admitting it. One recalls again the dark

11. Heinrich Wiegand Petzet, *Auf einen Stern zugehen: Begegnungen und Gespräche mit Martin Heidegger 1929–1976* (Frankfurt a.M.: Societäts-Verlag, 1983), 173.

12. In a marginal note in his copy of "On the Essence of Truth," Heidegger describes the "transition" between disclosure and a concealment intrinsic to it as: "der Sprung in die (im Ereignis wesende) Kehre" (*Wegmarken*, vol. 9 of *Gesamtausgabe* [Frankfurt a.M.: Vittorio Klostermann, 1976], 193). See also, among the many relevant texts, "Das Ende der Philosophie und die Aufgabe des Denkens," in *Zur Sache des Denkens* (Tübingen: Max Niemeyer Verlag, 1969), esp. 74; and *Beiträge zur Philosophie (Vom Ereignis)*, vol. 65 of *Gesamtausgabe* (Frankfurt a.M.: Vittorio Klostermann, 1989), 351f.

sea, the obscurity with which the coming of night fills the otherwise brilliant, bluish transparency of the water.

One thinks. One says that which is thought. And yet, what is thought and said will perhaps never coincide with what one can sense there under the Greek sun as it shines upon stone and sea. It is not even that what is thought and said proves different from what one can sense in traveling to Greece, except precisely insofar as it is something thought and said and not something sensed.

One could say even that what one can sense there on Delos confirms the thoughts and words brought along from beyond the Alps. Indeed, Heidegger's notebook takes on almost a tone of celebration in reporting that such confirmation is achieved through the stay on Delos. Marking the compounding of manifestation with concealment, the installing of untruth within the very essence of truth, that is, outlining the composition of ἀλήθεια, Heidegger declares that his long-cherished meditation on ἀλήθεια has found its confirmation on Delos. Thereby, by what is encountered on Delos, of Delos, the trip to Greece first becomes, says Heidegger, a sojourn (*Aufenthalt*). Thus the title that he gives to the notebook kept during the trip: *Aufenthalte*.

But how does the confirmation occur? There is perhaps no saying. But when Heidegger does undertake to say it in the notebook, the turn that he makes is remarkable yet at the same time puzzling. For he turns neither to the self-withholding stone nor to the dark sea but to the gods, or rather, to what was told of the gods in the ancient μῦθοι: what Delos shelters is the mystery of the birth of Apollo and Artemis. What Delos shelters is the holy, concealing it against every unholy intrusion.

Does one—can one—sense such sheltering in Delos or anywhere in Greece? Or are these only thoughts and words brought back from beyond the Alps? There is perhaps no saying. There is perhaps no deciding whether at this limit Heidegger draws back from the traces that one finds in the stone, sea, and ruins of Greece, replacing them with a story told everywhere. Heidegger writes of the invisible *of*— that is, belonging to—ἀλήθεια, the invisible that releases things into their visibility while withholding itself from all *Versinnlichung*.

And yet, if one is to encounter it, for example, in Delos, this invisible must announce itself as the invisible *of* the visible, must leave its inscription on the visible, must show a trace there amidst the shining of the visible. As with the dark sea. As with stone.

A few months later, back in Freiburg, Heidegger will write to Kästner about Delos: "I 'am' often on the island and think the whole of Greece from there."[13] Heidegger was not without reservations about immediate impressions. Many years earlier, following a ten-day visit to Rome, he had written to Jaspers that impressions did not have an immediate effect upon him but had to sink in only to return someday in memory (*Erinnerung*), seemingly stronger than in immediate presence.[14] Thus, it was not only a matter of impressions coming to confirm intuitively what had previously been thought, but also a matter of recollecting what had been seen, permeating it with reflection and with questions. Thus, in the same letter in which he writes of Delos Heidegger writes to Kästner of his entire trip to Greece: "And even today I can say only a little. This sea, these mountains, these islands, this sky—that here and only here Ἀ-λήθεια could emerge and the gods could enter into its sheltering light, indeed necessarily, that here Being held sway as presencing [*Sein als Anwesen waltete*] and human dwelling was established—for me all this is today more astounding and more difficult to think through than ever before."[15]

There are still other sites to visit, and for the most part they serve to bear out what had decisively occurred on Delos. In Athens of course there is much that must be broken through and set aside if anything properly Greek is to be found. But an early morning visit to the Acropolis before the arrival of the tourists (whom Heidegger constantly castigates—for example: they throw their memory away into the technically produced image) proves fruitful. It is the temple, the Parthenon, that engages Heidegger's responsiveness. He

13. Heidegger-Kästner, *Briefwechsel*, 52 (#17).

14. Martin Heidegger–Karl Jaspers, *Briefwechsel 1920–1963*, ed. Walter Biemel and Hans Saner (Frankfurt a.M.: Vittorio Klostermann and Munich: Piper, 1990), 161 (#122).

15. Heidegger-Kästner, *Briefwechsel*, 51 (#17).

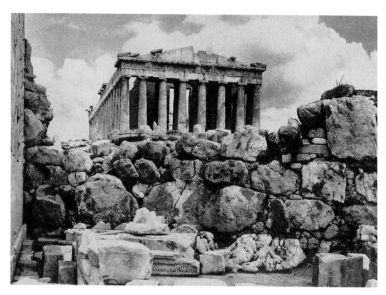

The Parthenon. Athens.

notes how it resists being merely beheld either from without or from within, offering no ready standpoint from which one can suitably engage it. Perhaps more than any other, it echoes, in a productive, confirming sense, what Heidegger had said twenty-five years earlier of the Greek temple as such: the temple gathers its lines and masses to the place, to its unique site, and, gleaming in the morning sun, the entire edifice seems suspended and yet thoroughly delimited in a presence akin to that of the rock on which it is erected. Heidegger says, too, that the temple is filled with abandonment by the holy one. One pictures its stones, shaped and assembled to form an open enclosure for the goddess, capable therefore of letting one now sense the absence of the goddess. Heidegger writes: "In it the absence of the goddess who has flown draws invisibly near" (*Auf.* 25). But why only invisibly? For the invisibility is one written on the stones once formed to enclose what has now flown. One senses the absence, senses it in the stones. As one never could without a sojourn in Greece.

A brief excursion by car to Sounion allows Heidegger the opportunity to see the temple of Poseidon, a temple *placed*—in the most decisive sense and perhaps more openly than any other—upon its rocky site between sea and sky. Of such placement Heidegger also had written twenty-five years earlier.

Another excursion, by boat, takes Heidegger to the temple at Aegina before he and his party travel on finally to Delphi, the culmination of the trip. In Delphi what engages Heidegger is neither the ruins of Apollo's temple nor the treasuries along the Sacred Way, but rather the *place*, "the greatness of the region itself," which surpasses "all human building." Heidegger writes: "Under the lofty sky, in the clear air of which circles the eagle, the bird of Zeus, the region itself was disclosed as the temple of this place" (*Auf.* 30f.). One recalls that it was also the eagle that once flew over the snow-covered peaks of Parnassus to follow northward over the Alps the course that will have been retraced southward on the return to Greece, the return finally to Delphi, a temple of earth.

Heidegger returns to the stone and light of Greece.

In 1967 he traveled to Athens to present a lecture entitled "The Origin of Art and the Destination of Thinking."[16] Not only does the lecture refer to artworks that Heidegger had seen during his travels in Greece (such as the Hercules Metope in Olympia), but also it determines its very point of departure by reference to the place, beginning thus with a reflection on the figure of Athena. In that reflection Heidegger comes to speak again of the stone and light of Greece.

Heidegger recalls Athena's epithet, γλαυκῶπις (with gleaming eyes), from γλαυκός, which names not only the gleaming of the eyes but also the shining of the sea, the stars, the moon, as well as the shimmer of the olive tree. He refers then to a sculpture in the

16. "Die Herkunft der Kunst und die Bestimmung des Denkens," in *Distanz und Nähe: Reflexionen und Analysen zur Kunst der Gegenwart*, ed. Petra Jaeger and Rudolf Lüthe (Würzburg: Königshausen und Neumann, 1983), 11–22.

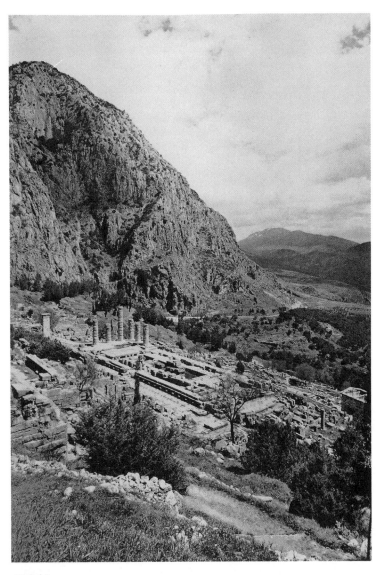

Delphi.

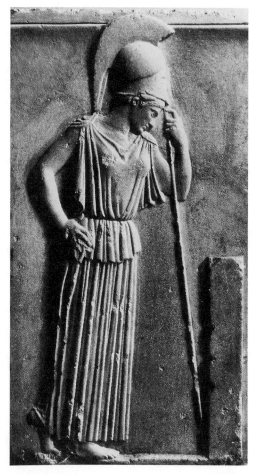

Votive relief known as "The Mourning Athena."
Acropolis Museum. Athens.

Acropolis museum (clearly he has in mind the votive relief known as "The Mourning Athena") and calls up the image that it presents of Athena: she is the σκεπτομένη, the one who looks carefully about, watching and considering. Heidegger translates: *die Sinnende*. Let me say: the one who senses, who, watching *and* consid-

ering, exemplifies in her activity the double sense of sense, even if dissolving the distinction in the unity of her activity. Heidegger asks with reference to the sculpture: to what is the sensing look of the goddess directed? He answers: to the boundary stone (*Grenzstein*), to the boundary, the limit. He notes, however, that the boundary or limit is not a line where something stops but rather is that by which something is gathered into its propriety (*in sein Eigenes versammelt*), in order from there to appear in its fullness. Watching and considering the boundary stone, sensing the limit, Athena has already in view that to which men must first look in order to bring what is seen forth into a work, and it is thus that Athena is the one who advises (πολύμητις). But in her sensing look the goddess considers not only the invisible form of works to be produced; she also casts her gaze upon the things that do not have to be produced, for example, the stone of the boundary stone, and upon that which lets such things come forth in their presence. The latter is what the Greeks called φύσις.

It is only in Greece, says Heidegger, that one can encounter the mystery of φύσις—in the way a mountain, an island, a coast, an olive tree appears. One hears it said that this is because of the unique light. Heidegger grants that this is to a certain extent correct, but he insists that it remains superficial, failing to consider that from which this strange light is granted. Only at the end of the Athens lecture does he return to the question of the Greek light, only after he has introduced the open (*das Offene*) as that which must already be freely in play in order for things to be lighted up, illuminated in their presence. But the open is thought by Heidegger as unconcealment: the mystery of the Greek light lies in unconcealment. The question of the Greek light leads back to the question of ἀλήθεια, which, in most but not all of his texts (and never without differentiations and reservations), Heidegger will translate as truth. The same can be said of stone.

It was indeed said, more than thirty years earlier, in a lecture that Heidegger first presented in Freiburg in 1935. An expanded version of the lecture was presented in Frankfurt in 1936 and finally pub-

lished in 1950 as *The Origin of the Work of Art*.[17] The title announces
an orientation to the artwork, an orientation that does not simply
govern Heidegger's investigation extrinsically, as if immune from
questioning; on the contrary, the orientation is itself tested in the
course of the investigation, other orientations—such as that to the
artist, to the creative process, or to the one who experiences the
artwork—proving to lead around to the orientation to the artwork,
requiring the latter for their proper grounding. Neither the mascu-
line aesthetics advocated by Nietzsche nor the feminine aesthetics
denounced by him suffices for thinking the artwork and its origin,
art as such. Indeed, Heidegger insists on the necessity of overcom-
ing all aesthetics and its characteristic appeal to experience—"the
element in which art dies." These words, from the Afterword to *The
Origin of the Work of Art*, are both echoed and extended in a letter
that Heidegger wrote some years later to Rudolf Krämer-Badoni,
responding to remarks that the latter had made about Heidegger's
1935–36 text. Heidegger writes: "The entire essay opposes the inter-
pretation of art in terms of 'mere art-enjoyment' [*vom 'blossen Kun-
stgenuss'*]. Thus, 'beauty' is not thought in terms of 'enjoyment'
[*'Gefallen'*], but rather as a way of shining . . . , i.e., of truth."[18] Art
and beauty are to be thought, not by reference to experience, to
αἴσθησις in its modern metaphysical interpretation, but in relation
to shining and truth.

17. References are, as previously, to "Der Ursprung des Kunstwerkes," in
Holzwege, vol. 5 of *Gesamtausgabe* (Frankfurt a.M.: Vittorio Klostermann, 1977).
This is the version presented in Frankfurt in November and December 1936,
slightly reworked and supplemented with marginal notes from the author's copy.
The version first presented in November 1935 to the Kunstwissenschaftliche Ge-
sellschaft in Freiburg has been published, along with a French translation, as: *De
l'origine de l'oeuvre d'art. Première version inédite (1935)* (Authentica, 1987). An
even earlier version, apparently never presented as a lecture, has been discovered
and has been published as "Vom Ursprung des Kunstwerks. Erste Ausarbei-
tung," in *Heidegger Studies* 5 (1989), 5–22. The text of the final version, as de-
livered in Frankfurt in the form of three lectures, initially appeared in the first
edition of *Holzwege* in 1950. A slightly reworked version, with an Introduction
by H.-G. Gadamer, appeared in 1960 in a Reclam edition.
18. "Ein Brief Martin Heideggers an Rudolf Krämer-Badoni über die
Kunst," *Phänomenologische Forschung* 18 (1986), 178.

Heidegger's proximity to Hegel is also marked in the Afterword to *The Origin of the Work of Art*, where, designating Hegel's *Aesthetics* as "the most comprehensive reflection on the essence of art that the West possesses," Heidegger focuses on Hegel's declaration of the pastness of art, citing those famous passages from the *Aesthetics*, and then writing—in the Afterword, after the end of *The Origin of the Work of Art*—that "a decision regarding Hegel's declaration has still not been reached" (*UK* 68). Thus, Heidegger leaves this giant question mark at the end of his essay, like a modern-day colossus casting its gigantic shadow back across that text.

All that mitigates that colossal question is a note that Heidegger wrote in the margin of his copy of the 1960 edition of *The Origin of the Work of Art*, next to his remark, in the text, about experience as the element in which art dies: "But this sentence does not mean that art is purely and simply at an end. That would be the case only if experience were the element *per se* for art. But everything depends precisely on getting from experience to Da-sein, and that says, after all: attaining a completely different 'element' for the 'becoming' of art" (*UK* 67 note b). This note stakes out a new path, one that would lead from reflection on art, from the redetermination of art that Heidegger's essay carries out, *back to art itself*, providing art with an element in which it could again *live*.

But of course the pastness of art is not, for Hegel, a matter primarily of its deadly assimilation to experience. Whatever may be the case with art in the element of experience, the pastness that Hegel attributes to it is of another order and remains for Heidegger a question. Not that Heidegger fails to mark the limits of his proximity to Hegel. Later, in the letter to Krämer-Badoni, he stresses that simply citing Hegel's declaration does not mean that he agrees with Hegel that art is at an end: "I 'can' not remain with Hegel, because I have never stood with him; this is prohibited by the abysmal difference in the determination of the essence of 'truth'."[19] The sensible shining of truth will never have been for Heidegger what it was for Hegel, nor will the dynamics of this concept of beauty have determined art to the pastness that Hegel's *Aesthetics* was to have

19. Ibid., 179.

sealed. For with Heidegger there is a turn in the determination of truth and in the interpretation of the sensible. One could say, risking a play, not quite controllable, abysmal: a turn in the sense of truth and in the truth of sense.

In *The Origin of the Work of Art* traces of stone are strewn throughout. Almost at the beginning, from the moment that Heidegger begins to orient the investigation of the artwork to its thingly character, stone comes upon the scene. Even the much-discussed aesthetic experience cannot—says Heidegger, his irony only thinly veiled—get around this thingly character (*Dinghafte*) that belongs to the artwork: "There is something stony in a work of architecture [*Bauwerk*]. . . . The architectural work is in stone" (*UK* 4). If one would proceed in view of the actual work, one needs to begin with this thingly character and then, only when it has been understood, go on to investigate the other element—the "genuinely artistic," one will call it—that is built upon the thingly substructure, brought together with it (συμβάλλειν) so as to make the work as such a symbol. Yet, in order to understand the thingly character of the artwork—the stone in which the architectural work *is*—one will first of all have to consider what a thing as such is.

"The stone in the road is a thing" (*UK* 5). But many other things also are—things. The extension of *thing* can be so broadened (the English at least as readily as the German *Ding*) that everything is a thing, whatever is not simply nothing. But many of these things one hesitates to call things: God, a peasant in the field, a deer in the forest clearing, a beetle in the grass, a blade of grass. Not even hammers, shoes, or axes are mere things: "Only a stone, a clod of earth, a piece of wood count as mere things" (*UK* 6).

Heidegger begins, then, by recalling—and by marking certain limits of—the major interpretations that Western thought has given of the thingness of the thing: "A mere thing is, for example, this block of granite. It is hard, heavy, extended, bulky, shapeless, rough, colored, partly dull, partly shiny. We can take note of all these features in the stone. Thus we acknowledge its characteristics. But still, the characteristics signify something proper to the stone itself" (*UK* 7). Thus, stone launches the exposition of the first of the interpretations of the thing, the interpretation of it as a bearer of proper-

ties. The block of granite reappears then in the third of these in-
terpretations: "The self-contained block of granite is something ma-
terial in a definite if unshapely form" (*UK* 13). It thus exemplifies
equally well the third of the interpretations of the thing (as formed
matter). Only in the second interpretation is stone not mentioned
as an example. Little wonder—since that interpretation dissolves the
thing into a mere unity of the manifold of sensations, depriving it
of that self-containment (*Insichruhen*) that stone, perhaps above all
other things, has.

The block of granite soon appears on the scene again, its self-
sufficiency contrasted with the character of a piece of equipment,
"for example, a pair of shoes" (*UK* 13). But now a shift of scene is
underway, and the curtain will soon open upon the artwork as such,
its thingly character being set aside, if only for a time—or rather,
upon examples, the first a particular painting of shoes by van Gogh.
From this point on, stone will come upon the scene only in—or in
proximity to—an artwork made of stone.

That artwork, a Greek temple, first appears after Heidegger has
been led, by way of the discussion of van Gogh's painting, to the
determination of the essence of art as the setting-(in)to-(the-)work
of truth (*das Sich-ins-Werk-Setzen der Wahrheit des Seienden*). One
of the questions prompted by this determination concerns imitation
(*Nachahmung*): Does this determination simply revive the tradi-
tional view that art is an imitation of reality? Heidegger's denounce-
ment of such an appeal to mimesis is no less vigorous than was
Hegel's critique of such a concept. Dismissing immediately the sup-
position that the artwork imitates a particular actual thing, Heideg-
ger turns to the supposition that the artwork reproduces the general
essence of the thing. It is in order to counter this supposition that
he brings onto the scene a Greek temple: "With what essence of
what thing is a Greek temple to agree? Who could maintain the
impossible view that the idea of temple is represented in the build-
ing?" (*UK* 22).

But how is the Greek temple brought forth? Whatever may be
the case with the pastness of art as such, there is no disputing the
pastness of such an artwork. The world to which it belonged has
disappeared, and along with that world the self-subsistence (*Insich-*

stehen) of the work "has flown from it" (*UK* 27), leaving it in ruins, regardless of its state of physical preservation. Bringing it forth will require recollecting the world to which the temple once belonged. Heidegger mentions also the Aegina sculptures in the Munich collection, noting how placing them in a collection has withdrawn them from their world—in this case withdrawing them even from the land still called Greece, northward over the Alps. One recalls Heidegger's response when, twenty-five years later, he visits the museum in Olympia, how he finds its sculptures (such as the Hercules Metope) both evocative and yet displaced from the world to which they once belonged, a world that the place itself, unlike Delos and Delphi, no longer evokes.

The pastness of the ancient artwork is not to be overcome even by encountering it in Greece, not even by coming before it at the very place where it belongs and still stands. Heidegger says that even if we "visit, for example, the temple at Paestum in its place . . . , the world of the work that stands there has perished" (*UK* 26). Even at its very site, bringing the temple forth, letting it shine forth as the artwork it is, will require recollecting the world to which it once belonged. It is only a question of the power of the ancient land and of the site of the temple to evoke such recollection, a question even of whether such recollection does not remain decisively, essentially limited as long as one has not visited that land and that site. Especially considering what Heidegger will say in the Athens lecture: that it is *only in Greece* that one can encounter the mystery of φύσις. But these are questions that do not belong to the essay of 1934–35. They come into play only when, twenty-five years later, Heidegger travels to Greece. Or rather, in the years just before his trip, the years of doubt and hesitation about the visit.

In *The Origin of the Work of Art* Heidegger thinks and writes of a Greek temple. Which one? The reference to visiting the temple in Paestum—introduced hypothetically and for the purpose of stressing the absence of the world of the work—occurs in all three versions of the text. But there are of course three temples in Paestum, built at different times and with considerable differences in their construction. There is no indication in Heidegger's text which of the three is meant, if indeed one of them is meant. Curiously, in

the second version of the essay (the one presented in Freiburg in 1935) Heidegger's description of the temple begins by calling it the temple of Zeus, but in the final, published version this specification is dropped, and he speaks only of "a Greek temple."[20] Though indeed there has been some uncertainty regarding the god or goddess to whom each of the three temples in Paestum was dedicated (this confusion is reflected in the names given the temples), none of the three seems to have been considered a temple of Zeus.

Is it even of a particular temple that Heidegger writes? Or is it of a temple in general, the idea of a Greek temple? Or does he write of something intermediate between a particular temple and the idea? Is it of something like the schema of a temple that he writes? Is his writing perhaps not, then, so free of imagination as one might suppose?[21] As when, for example, he writes of the world of a Greek temple: "A building, a Greek temple, portrays nothing. It stands simply there in the middle of the rock-cleft valley. The building encloses the figure of the god and lets it, in this concealment, stand out through the open colonnade into the sacred precinct. By means of the temple the god is present in the temple. This presence of the god is in itself the extension and delimitation of the precinct as a sacred precinct. The temple and its precinct, however, do not fade away into the indefinite. It is the temple-work that first fits together and at the same time gathers around itself the unity of those paths and relations in which birth and death, disaster and blessing, victory

20. In the second version the relevant sentence reads: "Der Zeustempel steht da, inmitten des zerklüfteten Felsentales" (*De l'origine*, 24). In the final version this is replaced by the following two sentences: "Ein Bauwerk, ein griechischer Tempel, bildet nichts ab. Er steht einfach da inmitten des zerklüfteten Felsentales" (*UK* 27).

21. The reference is to schema in the Kantian signification as interpreted by Heidegger, who emphasizes both its intermediate position between concept and image and its connection with imagination. See *Kant und das Problem der Metaphysik*, vol. 3 of *Gesamtausgabe* (Frankfurt a.M.: Vittorio Klostermann, 1991), esp. §§20–21. The first edition of this work appeared in 1929. One might suppose, on the other hand, that by 1935 imagination no longer plays such a significant role for Heidegger, especially considering the remark that he makes in *The Origin of the Work of Art*, putting in question the adequacy of an appeal to imagination for thinking the essence of *Dichtung* (*UK* 60).

and disgrace, endurance and decline acquire the shape of destiny for human being [*dem Menschenwesen die Gestalt seines Geschickes gewinnen*]. The all-governing expanse of this open relational context [*Die waltende Weite dieser offenen Bezüge*] is the world of this historical people" (*UK* 27f.). The world, which has to be recollected—perhaps in imagination—as one writes of it, is not only a setting for the temple, is not only something to which the temple would belong; rather, the world is also something itself gathered, opened up, and held in play by the temple.

Only at this point, having thus brought forth the world of the temple, does Heidegger turn to the stone *of* which the temple is built and to the stone *on* which it is built. Here is how he begins to write of the stone of the temple: "Standing there, the building rests on the rocky ground" (*UK* 28). There—granting a place where, as with every artwork, truth can take place—there it is, above all, a matter of standing, of the support that allows a temple to stand. But now it is no longer, as in the Hegelian recollection, a matter of the way in which the columns give shape to the supporting so as to let the purposiveness of the temple shine forth, the supportiveness by which it is capable of providing an enclosure for the god. It is not with the form of the work itself that Heidegger begins, but rather with a double support through which the work is linked to what lies beneath it and what opens above it. Beneath it, supporting it, is the rocky ground (*Felsgrund*): in being supported, in resting on the rock, the temple draws up from the rock the darkness of its massive support, thus bringing to the light of day, thus letting shine, that obscure, massive ground, letting shine forth the very darkness of the rocky support. Heidegger says that this supporting is not impelled to anything (*zu nichts gedrängten*): it is utterly without prescribed purpose, utterly unpurposive, in starkest contrast to the columns on which Hegel fixes his gaze and in which he sees the purposive support given shape and made to shine. Whereas columns are designed to support a temple, the rocky ground on which the temple is erected can support any and every kind of edifice. Heidegger continues: "Standing there, the building withstands the storm raging above it and so first makes the storm itself manifest in its

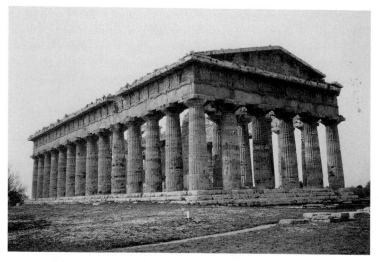

The Temple of Hera I, so-called Temple of Poseidon.
Paestum. 5th century B.C.

violence" (*UK* 28). The temple not only is supported by the rocky
ground but also bears its support within itself, standing there under
the raging storm, making manifest, as Heidegger says, the storm,
the force of the storm, but also, in its resistance to that force, letting
its own self-support become manifest.

Then it is as if the thunderstorm had passed, the sun now reap-
pearing from behind the dark clouds, shining upon the stone of the
temple, still dripping with rain, glistening as the rays of sunlight
strike it. Now, after the storm, Heidegger writes of the shining of
stone: "The luster [*Glanz*] and gleam [*Leuchten*] of the stone, itself
shining, it seems, only by the grace of the sun [*anscheinend selbst
nur von Gnaden der Sonne*], nonetheless first brings the light of day,
the breadth of the sky, the darkness of night to shine forth [*bringt
. . . zum Vorschein*]" (*UK* 28). Heidegger adds: "The temple's firm
towering makes visible the invisible space of the air." Nothing that
Heidegger ever wrote is more contrary to sound common sense than
what he writes here about the shining of the temple's stone. Not

only does it invert common sense, but—in a figure that it would be difficult to compose—it also inverts in the same move precisely what Hegel delimited as the inversion of common sense, namely, metaphysics, philosophy as such. For both common sense and metaphysics would take it for granted that there is, first of all, the open space of the air and sky within which the light of day would shine forth in natural alternation with the coming of the darkness of night. Despite all inversion, despite all the magical power to turn the negative into being, even Hegel's metaphysics would still take being for granted, as granted in the granting of a beginning; still it would take for granted the "there is"—both in the sense of the *es gibt* (something is given, granted) and in the sense of there being already a *there*, a place, a *Da*, in which then something like the stone of the temple could come to shine. Heidegger reverses this—or, more precisely, sets it revolving, circling. Even if the shining of the temple's stone seems to require—and in a sense certainly does require—the shining sun, still it is the shining of the artwork that opens and sustains the space of air and sky in which things can come to the light of day and recede into the darkness of night. Heidegger writes: "The temple, in its standing there [*Dastehen*], first gives to things their look and to men their outlook on themselves"—just as, for example, a sculpture of the god, rather than being a portrait meant to facilitate realizing how the god looks, "lets the god himself be present" (*UK* 29). It is through the shining of the artwork that there is an open place in which things can come and go, coming up, blossoming, yielding fruit in the bounteousness of summer, receding, withdrawing almost as in death, in the starkness of winter.

Such coming and going is what the Greeks called φύσις. Heidegger translates: *Aufgehen*. Let me, without pretending to translate, simply say: *coming*—both coming up (as the sun comes up each morning and as a plant comes up from the seeds planted in the ground) and coming forth (as things coming up from the earth come forth into the air and light, as a plant, in blossoming, lets its flower come forth). In a contemporaneous text, *Introduction to Metaphysics*, Heidegger writes: "φύσις as *Aufgehen* can be experienced everywhere, e.g., in celestial occurrences (the rising of the sun), in the rolling of the sea, in the growth of plants, in the com-

ing forth of man and animal from the womb."[22] Much later, in the Athens lecture Heidegger speaks of φύσις in the context of his description of the sensing look that Athena casts on the boundary stone, calling it "that which of itself comes into the boundary peculiar to it and tarries therein."[23] It is in this context that he says that one can encounter the mystery of φύσις *only in Greece.* And when he was himself in Greece, when, telling how on Delos his trip first became a sojourn in Greece, he comes to write of φύσις, he calls it "the pure self-sheltered coming forth of the mountains and islands, of the sky and the sea, of plants and animals, the coming forth in which each appears always in its rigorously inscribed yet gently suspended figure" (*Auf.* 21).

Recalling the fateful translation of φύσις as *natura,* nature, one realizes that Heidegger is reversing the relation between art and nature that has remained largely in force since the Greeks, the relation in which art as mimesis is subordinated to nature, which it would imitate, which it would mimetically reproduce in an image distinct from the natural original. Because of its mimetic character, a secondariness is ascribed to art throughout much of the history of metaphysics from Plato on. Hegel's critique of mimesis withdraws art from this subordination to nature, redetermining it as another kind of mimesis, that by which art is the sensible presentation of spirit. Here, then, a certain reversal of the relation between art and nature already comes into play. This reversal is expressed when Hegel writes, at the very outset of the *Aesthetics,* that "the beauty of art stands *higher* than nature; for the beauty of art is beauty born and reborn from spirit" (*A* 1:14). And yet, the Hegelian reversal only reconstitutes the secondariness of art in another direction rather than canceling that secondariness: art is no longer secondary to nature but to spirit, and it is the incapacity of art to measure up to spirit, to accomplish an adequate presentation of spirit, that destines art to the seal of pastness. The Heideggerian reversal is different: it is determined, not by the concept of spirit, but, as Heidegger told

22. *Einfuhrung in die Metaphysik,* vol. 40 of *Gesamtausgabe* (Frankfurt a.M.: Vittorio Klostermann, 1983), 16.
23. "Die Herkunft der Kunst und die Bestimmung des Denkens," 14.

Krämer-Badoni, by "the abysmal difference in the determination of the essence of 'truth'." For Heidegger it is a matter of a reversal that cancels the secondariness of art precisely on the basis of the relation of art to abysmally redetermined truth. Thus, in characterizing the move as one of reversal, Heidegger is careful to add qualifications: " . . . assuming of course that we have, in advance, an eye for how differently everything then turns toward us. Mere reversing, done for its own sake, yields nothing" (*UK* 29). The Heideggerian reversal is such that neither nature nor spirit (to the extent that Heidegger reconstitutes the concept of spirit)[24] would simply precede art, consigning it to the secondariness of mimesis. Not even truth would precede art, neither the truth of nature, nor the truth of spirit, nor the truth that Heidegger thinks, in its abysmal difference, as ἀλήθεια, as first opening the space in which anything like nature and spirit can come forth, come and go. For art is one of the ways—though not the only one—in which truth happens, and truth does not antedate its happening.

Heidegger's remarkable little discourse on the temple's stone concludes by delimiting a ground. He characterizes it as the ground of human dwelling and delimits it in reference to φύσις. This ground he proposes to call *earth*. It is, he says, that to which the things that come up, that come forth into the light, are brought back and sheltered, secured. Almost as those who have lived and died are brought back and their memory secured by the gravestones in the Prague cemetery. For, indeed, what is more properly of the earth than stone? Perhaps even when its materiality is interrupted. Perhaps even when its shine makes it appear to renounce its ancient heaviness and to soar into the heavens.

Reversing the relation between art and nature, undermining the classical concept of art as mimesis, Heidegger regards the temple as opening the space of air and sky, as freeing the expanse in which things can come up into the light of day. Thus opening a world,

24. Jacques Derrida traces perceptively the various stages and strategies by which Heidegger came to rehabilitate the concept of spirit. See *De l'esprit: Heidegger et la question* (Paris: Galilée, 1987), along with my discussion in "Flight of Spirit," *Diacritics* (1989), 25–37.

the temple also brings forth the earth as that to which the things that come up into the light are brought back and secured. In Heidegger's words, "The temple-work, standing there, opens up a world and at the same time sets this world back again on the earth which itself only thus comes forth as home ground [*als der heimatliche Grund*]" (*UK* 28).

Heidegger extends his discourse on the temple, weaving it back and forth between world and earth, delimiting the artwork as the being through which world is set up (*aufstellen*) and earth set forth (*herstellen*), more precisely, as the being that gives place to the strife of world and earth, to their πόλεμος. It is as such that truth takes place in art. Not that truth somehow first subsists in itself—heaven knows where!—and then comes to be exemplified or presented in the artwork. On the contrary, *there is* such truth only insofar as a being, the artwork, is brought forth so as to give place to truth. The truth *of* art comes about only as the truth *in* art, only insofar as truth sets itself to work in the work. Art does not present a truth that would precede it (as an original precedes an image) or that would exceed it and be capable finally of making it for us something past. Art is the taking place of truth, a way in which truth happens.

As Heidegger weaves his discourse there are several turns at which it is drawn back to stone, almost as if to borrow the support, the weight. As the discourse turns around world, it is, for instance, declared that stone is worldless, and a contrast is drawn with men, who have a world in which they are open to other beings and themselves, and even with plants and animals, which, though they have no world as such, are linked to a surrounding (*Umgebung*). This configuration of distinctions derives from the extended investigation of world that Heidegger undertook in his 1929–30 lecture course *The Basic Concepts of Metaphysics*. There he distinguishes between three ways of investigating world: first, by tracing the history of the word (as in *On the Essence of Ground*); second, by interpreting the everyday understanding of world (as in *Being and Time*); and, third, by a comparative investigation. It is the last of these that he undertakes in the 1929–30 lectures. He sets up the framework of the investigation by formulating the following three theses: 1. the stone is worldless (*weltlos*); 2. the animal is world-impoverished (*weltarm*);

3. man is world-formative (*weltbildend*). One of the ways in which he immediately marks the difference between the stone and the animal is through the relation to life and death: "A stone cannot be dead, because it does not live."[25] Heidegger does not pause, however, to consider the relation that a stone, for example, a gravestone, can have to the dead whom it memorializes and to the living for whom it serves to bring the dead back in memory.[26] The other distinction, between man and animals, he formulates as the difference between having and not having a world: man has a world, whereas the animal lacks, is deprived of (*entbehren*), a world.[27] On the other hand, the stone is so utterly worldless that it cannot even lack, be deprived of, a world—no more than it can, in death, be deprived of life. Unlike the animal, the stone has no access to other beings, and Heidegger sharply contrasts the stone's "resting" (as one says, improperly) on the earth with the "relation that a lizard has to the stone when lying upon it in the sun."[28]

But to declare that stone is worldless does not mean that it cannot enter a world, that it cannot be taken up into a world that opens around it or above it. One can say of stone in particular what Heidegger says of everything: that through the opening up of a world it gains its lingering and hastening, its remoteness and proximity, its breadth and narrowness. And yet, what is most remarkable is that,

25. *Die Grundbegriffe der Metaphysik: Welt-Endlichkeit-Einsamkeit*, vol. 29/30 of *Gesamtausgabe* (Frankfurt a.M.: Vittorio Klostermann, 1983), 265.

26. In *Being and Time* Heidegger's account of the death of others includes a discussion of the way in which those who live on are with the dead in mourning and commemoration. Though he mentions funeral rites, burial, and the cult of graves, he does not mention gravestones as such (*Sein und Zeit*, 9th ed. [Tübingen: Max Niemeyer Verlag, 1960], 238).

27. Heidegger's strict distinction between the human and the animal reappears in a larger and more decisive context in *Letter on Humanism* (*Brief über den Humanismus*, in *Wegmarken*, vol. 9 of *Gesamtausgabe* [Frankfurt a.M.: Vittorio Klostermann, 1976], esp. 321f.). The distinction and the strictness that Heidegger ascribes to it have been addressed critically by Jacques Derrida in "*Geschlecht* II: Heidegger's Hand," in *Deconstruction and Philosophy* (Chicago: University of Chicago Press, 1987), and in *De l'esprit*; also by David Krell, *Daimon Life: Heidegger and Life-Philosophy* (Bloomington: Indiana University Press, 1993).

28. *Die Grundbegriffe der Metaphysik*, 290.

worldless though it be as such, stone can come to have the most intimate relation to world when a temple is built from the stone, a relation so intimate (*innig*) that the stone is what draws the world opened by the temple into its full sway.

What is decisive, then, is the way in which stone enters a world when something is made of that stone, when an artwork is made from such material (*Werkstoff*), when, for example, a temple is set forth (*herstellen*) from stone, made (as we say) out of it. Heidegger contrasts such making with that involved in fabricating equipment: when stone is used for making an ax, it is used up, in the sense that its materiality disappears into the serviceability of the ax, and the material is more suitable the less it resists being absorbed into the equipmental character of the ax. What matters is, not the stoneness of the ax, but only its serviceability for performing its function. This is why, with technical advances, one has not the slightest hesitation about replacing a stone ax with the more serviceable one that can be made from metal. Indeed, in more technically advanced countries one no longer finds stone axes, if even axes at all. In the half-century since Heidegger chose this now—and perhaps even then—almost quaint example, stone axes have been replaced—if they were not already then—by more serviceable equipment. They have passed out of use, have become for us something past, something hardly likely to be called back, something that there is little need to recall.

The stone of the temple is utterly different: "By contrast the temple-work, in setting up a world, does not let the material disappear, but rather lets it come forth for the very first time, to come into the open of the work's world" (*UK* 32). In the temple, then, the stone does not disappear but, on the contrary, is set forth into the very world that the artwork opens up; it comes to show itself as such in that world, to shine forth as stone. Indeed, the temple lets its stone thus shine precisely because of its way of being made of stone: the stone of the temple comes to light as bearing its weight, as supporting, not simply in the aspect of the columns, but rather, says Heidegger, "as the work sets itself back into the massiveness and heaviness of stone" (*UK* 32). Setting itself back into stone, being made of stone, the temple lets stone come forth into the world thus opened up, lets it come forth and show itself there as stone. And

even if, with the advance of technology, other materials prove more serviceable or even more artistically pliant, even if eventually all buildings are made of steel, glass, and concrete, there will still be need to call back buildings of stone, to remember the Greek temple. Even though it could never have soared into the heavens like a Gothic cathedral, to say nothing of the skyscrapers that now tower above our cities—like those enormous phallic columns erected in ancient India, like the obelisks of ancient Egypt, like the Tower of Babel, but now built without being impeded by the intractableness of stone, built so as almost to appropriate the material (steel, glass, concrete) to the work, built so as almost to make it disappear in these colossal machines fabricated for housing human life, these machines for living, as Le Corbusier called them. Still, even today, if one would know what stone is, the most propitious way would be to recall the temple, to bring oneself before its ancient stones, to let their silence resound.

But it is not only a matter of stone, which in a sense is just an example. It is a matter of earth as such. Heidegger writes: "That into which the work sets itself back and which it lets come forth in the setting back of itself we call earth." He concludes: "The work brings the earth itself into the open of a world and keeps it there. *The work lets the earth be an earth*" (*UK* 32). And yet, stone is more than just an example. For what is more properly *of the earth* than stone? If stone is indeed most properly of the earth, then it is capable of setting forth the earth—of letting the earth come forth and be disclosed as such—in a more appropriate way than other so-called materials, and one could accord a certain privilege to those arts capable of composing in stone, a privilege limited to this connection of course but as such serving to give to architecture and sculpture a certain propriety, a certain resistance to being ordered in a linear sequence of the arts. One would in any case have to complicate the apparently simple series that is posed when Heidegger lists materials from which various kinds of artworks are made: "stone, wood, metal, color, language, tone" (*UK* 31). If one thinks beyond the concept of mere material, beyond the mere correlation of matter and form (which Heidegger has himself dismissed in criticizing the third of the interpretations of the thing), then can one suppose that in a

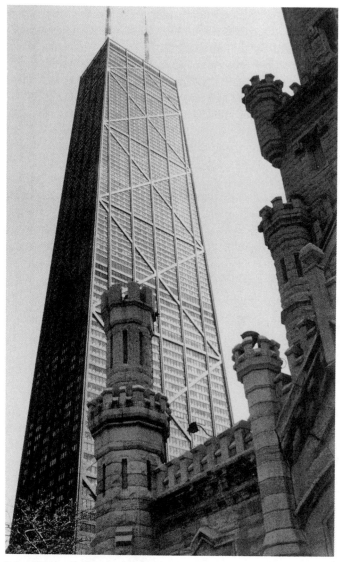

John Hancock Center. Chicago.
Built in 1969 of steel, aluminum, and glass.
One hundred stories high.

poetic work language sets forth the earth as stone sets it forth in the temple? Is there not a need here for further differentiation, for a more articulated schema? Would not such a schema, acknowledging the proper privilege of stone and of works made of it, necessarily have to complicate the unconditioned privilege that Heidegger finally comes to ascribe to the linguistic work of art, to *Poesie*, over against works of architecture, sculpture, etc. (see *UK* 60f.)?

But what is stone that it comes to be disclosed precisely in this way, in the artwork? Could it not be known more directly, by being simply brought to light, opened up to view? Heidegger writes: "The stone presses downward and manifests its heaviness. But while this heaviness presses against us, it denies us any penetration into it. If we attempt such a penetration by breaking the rock to pieces, it still does not display in its pieces anything inward and opened. The stone has instantly withdrawn again into the same dull press and bulk of its pieces" (*UK* 33). Yet, one may then try another, less direct, seemingly less violent way. Heidegger continues: "If we try to grasp the stone's heaviness in another way, by placing the stone on scales, we merely bring the heaviness into the form of a calculated weight. This perhaps very precise determination of the stone remains a number, but the press of its heaviness has withdrawn from us [*das Lasten hat sich uns entzogen*]. . . . It shows itself only when it remains undisclosed and unexplained. Earth thus shatters every attempt to penetrate into it" (*UK* 33). Thus does earth escape, despite all devastation, the calculative assault of technology. Thus also could stone, since it is most properly of the earth, mark a certain limit of technology.

Like the earth to which it belongs, stone shows itself only when it is brought into the open *as* self-secluding, as closed off, as self-closed. This is what the artwork and only the artwork can do; this is what the temple does precisely by its way of being made of stone.

Especially if one were willing to let it show itself as stone, bringing oneself, for example, before the ancient stones of a Greek temple, stone could become a boundary stone marking the bounds of technological appropriation, indeed of every economy of assimilation. Stone would be like the foreigner whom one would not merely integrate but would be bound also to recognize and accept in his

alterity. And yet, at the same time, nothing seems less alien than mere stone, than the earth as it "comes forth as home ground." The very constitution of home and ground would be reconfigured by the admission of the stranger, recast as an identity belonging to difference.

Because it is made of stone, the temple sets forth earth into the open, the world, and thus gives place to that strife of world and earth that Heidegger identifies as the truth of art. Yet, the truth *of* art is also a truth *in* art, that is, truth is not only set to work but set into the work. Thus, having characterized the strife of truth as a rift (*Riss*),[29] Heidegger writes: "The rift must set itself back into the drawing weight of stone . . . " (*UK* 51)—the word *drawing* (ziehend) evoking the figure of truth being pulled toward, drawn into the work, and, first of all, into the stone of which the work is made. Indeed, it is not even as if the truth first *is* and then comes to be set into the work; rather, the truth of a work of stone first happens when that truth comes to be drawn in stone. No longer is the stoneness of the temple something that would limit its capacity to present truth in its proper depth, that would, hence, prevent the temple from bringing the truth to one at that depth, consigning it to the past, making the temple for us something past. On the contrary, its stoneness is precisely what allows it to present—or rather, to give place to—the impenetrable depth of truth, the self-closure of earth; it is what first lets truth in its abysmal difference happen, take place.

In a letter of March 1969 Heidegger writes to Kästner of his recent and upcoming travels, not to Greece but in the area around Freiburg; he has just returned from Switzerland and looks ahead to a trip to his brother's in Messkirch. But on the very next day, he tells Kästner, he will have to go "to St. Gallen in order to write the text on stone [*um den Text auf Stein zu schreiben*]."[30] The text to

29. Here I take the liberty of referring to the more systematic and detailed interpretation that I have given of this and other relevant developments in Heidegger's essay in *Echoes: After Heidegger* (Bloomington: Indiana University Press, 1990), chap. 7.

30. Heidegger-Kästner, *Briefwechsel*, 106 (#45).

which he refers is the very brief essay *Art and Space*. If one puts into play the double meaning introduced through the translation of *auf* as *on*, then one might say that this is a text doubly on stone. It is about an art that can produce its works in stone, namely, sculpture. Indeed the report is that the text was prompted by Heidegger's interest in the work of Eduardo Chillida and first appeared along with seven litho-collages by the Basque artist.[31] It is almost as if the text were written in the margin of *The Origin of the Work of Art*: characterizing art as the bringing of truth into the work, Heidegger focuses on the decisiveness that space or place has for sculpture. Sculpture he calls the embodiment of place, or, more precisely: "an embodying bringing of places into the work [*ein verkörperndes Ins-Werk-Bringen von Orten*] and, with this, an opening up of regions for possible human dwelling and for a possible staying of the things that surround and concern man."[32]

But the text was also written on stone. Heidegger had to travel to St. Gallen—in Switzerland, north of the Alps—in order to inscribe the text by hand on lithographic stone. It is as if he wanted to enact the setting of truth into stone, to set even the truth of thinking back into the drawing weight of stone, to draw it toward, to inscribe it upon, that which is most properly of the earth. As if even the privilege of language could be interrupted by stone.

When Heidegger's friend Heinrich Petzet tells of the venture in St. Gallen, he says only that for the philosopher, untrained in such artistic practices, this work was not easy.[33]

31. Ibid., 149. Also Petzet, *Auf einen Stern zugehen*, 161–167.
32. *Die Kunst und der Raum* (St. Gallen: Erker-Verlag, 1969), 13.
33. Petzet, *Auf einen Stern zugehen*, 166.

5

THEATRE OF STONE

IMAGINE IT. Picture the scenes that might be staged by a very skillful stonemason practicing a kind of lithography with his chisel or by the philosopher writing at the limit of philosophy, there in St. Gallen writing a text doubly on stone, making stone speak of itself. This enactment reflects what Heidegger undertook to have everything do: even when he no longer gathered his thinking under the name *phenomenology*, that thinking remained no less submitted to the things themselves, rigorously drawing what it would say of things from those things themselves, even determining the very sense of rigor by the demand that the things themselves be brought, in their proper way, to speak and that thinking limit itself to echoing in its own element what the things themselves would already have said.[1] This is what was enacted there in St. Gallen, the philosopher intervening with his untrained hand to make stone speak of itself.

Such a scene can actually be beheld. For example, in a performance of Shakespeare's *The Winter's Tale*.[2] Here, too, but now in theatre that is no longer lithography, stone comes to speak, indeed to speak of itself. Though the play does not lack reference to things written—or not written—on stone (I.ii.360), here it is not primarily a matter of writing but of speech sounding forth from the scene presented; it is not even a matter solely of speech but also—and

1. Such a determination of thinking is said in the title of Heidegger's late work *Zur Sache des Denkens* (Tübingen: Max Niemeyer Verlag, 1969). See especially the final text in this work, "Mein Weg in die Phänomenologie."
2. Citations from *The Winter's Tale* are from the Arden text edited by J. H. P. Pafford (London: Routledge, 1963).

everything hinges on this *also*—of presentation, showing, spectacle. In a word, shining.

In the theatre word and vision, the two senses set apart in the abysmal doubling of sense, come to belong together in a manifest accord—which is also to say an irreducible difference—that is perhaps never possible in philosophy, not even at the limit. Nothing more, at most, than its mere schema, drawn by the untrained hand of the philosopher who makes stone speak of itself. Even if only imagined from afar at the outset, there can have been no doubt but that the trajectory would lead finally to the theatre, to a theatre of stone.

Shakespeare did not invent the basic story and main characters of *The Winter's Tale* but took them from Robert Greene's *Pandosta*. Yet in doing so he introduced some essential alterations in the story, most notably, preserving and finally reuniting the king and queen whom jealousy and the semblance of death had separated. Also he adds some characters of his own, while transforming and renaming those in *Pandosta*, giving them proper names in the most proper sense. An initial orientation to *The Winter's Tale* can be provided by regarding it as a configuration of these proper names, the dynamics of the play consisting in a series of flights, returns, and substitutions among those thus properly named.

In some cases the propriety of the name is etymologically transparent, as with Leontes, around whose name, along with that of his queen Hermione, virtually all the others are configured. The king is named for his leonine quality, not only for the nobility of the lion but equally for the danger that he represents for all around him, the wrath that he displays. Cast as the King of Sicilia (rather than of Bohemia, as in *Pandosta*, switching countries with the other monarch)[3] Leontes is driven by his kingly wrath, his tyrannical jealousy,

3. The lion is proverbially the king of the beasts. Randall points out that King James' crest "bore no less than thirteen of these royal animals" and that "in 1603 at the beginning of his reign, Parliament was assured that 'The prince's command is . . . like the roaring of a lion.' " He cites also Proverbs 19:12 (in the 1576 Geneva version): "The Kings wrath is like the roaring of a lyon." Randall also suggests that Shakespeare may have cast Leontes as King of Sicily "because of its age-old fame for wrathful kings." He notes, too, the association that the

to accuse his queen of committing adultery with Polixenes, King of Bohemia, and even of carrying a child by the latter, his lifelong friend, who for nine months has been a guest at the court in Sicilia. Through this accusation, proclaimed publicly, Leontes unleashes a sequence of monstrous events. Once he orders his most trusted advisor Camillo (whose name, taken from Plutarch, connotes moderation in command and astute judgment and wisdom)[4] to murder Polixenes, Camillo has no choice but to inform the Bohemian monarch and to flee with him to Bohemia. Then the events become truly monstrous: the daughter to whom Hermione gives birth Leontes rejects as a bastard and banishes to a foreign land (Bohemia, as it turns out) where she is to be abandoned to chance. Leontes' madness persists even when word arrives from the Oracle:

> Hermione is chaste; Polixenes blameless; Camillo a true subject; Leontes a jealous tyrant; his innocent babe truly begotten; and the king shall live without an heir, if that which is lost be not found.
>
> (III.ii.132–135)

His madness dissipates only when the monstrous events continue, only when his denunciation of Apollo's Oracle brings a servant announcing the death of the young prince Mamillius. At the announcement of the boy's death, Hermione faints and is soon reported dead herself. Sixteen years of repentance pass before Leontes is reunited with his long-lost daughter, properly named Perdita,

king's name could have had with *Leontini*, one of the first Greek colonies in Sicily, founded about 729 B.C. and roughly equidistant between Aetna to the north and Syracuse to the south (Dale B. J. Randall, "A Glimpse of Leontes through an Onamastic Lens," in *Deutsche Shakespeare-Gesellschaft West: Jahrbuch*, 1988, 123–126).

4. In North's translation, used by Shakespeare, the relevant passage reads: "He behaved him selfe in such sorte, that when he was alone, he made his authoritie comon to other: and when he had companions and associates, the glorie of all redounded to him self alone. The cause whereof, was his modestie on the one side, for he commaunded ever without envie: and his great wisedome and sufficiencie on the other side, for the which all others willingly gave him place, and yelded to him" (Plutarch, *The Lives of the Noble Grecians and Romanes*, translated by Thomas North from James Amyot's French translation of the Greek. First published in 1579. [Reprinted: London: The Nonesuch Press, 1927], 1:234).

and, in the magical final scene, with Hermione herself, returned as if from death.

In the pastoral scene just preceding her return to Sicilia, Perdita is addressed as the goddess Flora by her lover, who virtually shares the name; Prince Florizel ventures also to compare himself, clad as he is for the rustic sheep-shearing festival, to "golden Apollo" who for the sake of love disguised himself as "a poor humble swain" (IV.iv.30). Indeed, it is his love for Perdita that, prohibited by Polixenes, drives them to return to Sicilia, thus in effect fulfilling the Oracle. When they arrive at Leontes' court, Perdita's identity is still unknown. But looking upon Perdita, Leontes thinks of Hermione (V.i.226–227), sees her in her daughter, whose look represents, substitutes for, that of the queen withdrawn by the semblance of death. This substitution is borne in the name: one of the mythological narratives in which Hermione's name occurs identifies it as a title of both Demeter and Persephone.[5] *Hermione* is also the name of the town where the rape of Persephone is said to have happened and where there was said to be an entrance to the underworld.[6] It was through this entrance that Persephone was carried off by the king of the dead, one of whose names, Polyxenos,[7] is virtually shared by the King of Bohemia, whose suspected affair with Hermione leads to her semblance of death, from which she returns only at the end of the play, as in the tale of Persephone's return from the realm of the dead at the end of bitter winter. Indeed, in *The Winter's Tale* Perdita invokes the name of Persephone, associating it with "flowers o' th' spring" (IV.iv.113, 116).

There are also other substitutions. One such representative is played under the name *Antigonus*, which is taken from Plutarch, who describes one so named as he "who was of the greatest power of all the captaines and successours of Alexander the great."[8] An-

5. Inge Leimberg, " 'The Image of Golden Aphrodite': Some Observations on the Name 'Hermione,' " in *Deutsche Shakespeare-Gesellschaft West: Jahrbuch*, 1988, 130. See also *The Oxford Classical Dictionary*, 2nd ed. (Oxford, 1970), 504.

6. Leimberg, " 'The Image of Golden Aphrodite,' " 130.

7. *Der Kleine Pauly: Lexikon der Antike* (Munich: Deutsche Taschenbuch Verlag, 1979), 4:1014.

8. Plutarch, *Lives* (North translation), 2:6.

tigonus is, it seems, chief among Leontes' Lords, though by the time the question of Leontes' successor is compared to the case of "great Alexander" (V.i.47), Antigonus has long since met a violent death ("torn to pieces with a bear" [V.ii.64]) on the mission that he carries out for Leontes, executing as surrogate the king's expulsion of the allegedly bastard daughter to a foreign land. It is Antigonus' wife Paulina who draws the comparison with Alexander, doing so precisely in order to allay the concern about Leontes' successor and thus to forestall any thought of remarriage. Paulina becomes the representative of Hermione, getting Leontes to promise that he will marry only one chosen by her; thus representing the seemingly dead queen, she keeps the place open for Hermione's return in the final scene. Only then, when the queen has returned to her place beside Leontes, does the king propose Paulina's marriage to his own recently returned representative Camillo.

There are others, most notably, Autolycus, a thief, named for the son of Mercury, the thief among gods, the god of thieves. The association of the god's Greek name with *Hermione* extends the propriety: Hermes was sent to the underworld by Zeus to persuade Hades to release Persephone and allow her to return to the earth, which in her absence, because of the sorrow of her mother Demeter, had become a virtual desert. Autolycus, too, the Autolycus of *The Winter's Tale*, plays a decisive role in the chain of events that lead finally to Hermione's return as if from the dead.[9] Indeed, his role is less decisive than he, scheming always for his own advancement, would have liked it to be, but, had he not brought aboard the ship to Sicilia the only persons with evidence of Perdita's identity, the fulfillment of the Oracle and the return of Hermione would not have followed.

Those who possess such evidence, who found the infant along

9. Various other attributes of Hermes are mirrored in the Autolycus of *The Winter's Tale* and in his diverse functions in the play. Hermes was the god of wayfarers and of the road and was said to appear suddenly to offer guidance to those underway. As such he was associated with boundary stones as well as with gravestones; indeed, his name, according to Guthrie, clearly means "he of the stone-heap." He was also associated especially with shepherds and with the marketplace. See W. K. C. Guthrie, *The Greeks and Their Gods* (Boston: Beacon Press, 1950), 87–94.

with the letters, jewels, and fardel left with her—these persons have no proper names in the play. They are common fellows called by common names, the names *shepherd* and, for his son, *clown*. There are others, too, named in this common way, most notably, the character who makes up the one-person chorus that speaks but once and then only to announce a gap in the middle of the play, a gap with the same name as the character himself, who is named *time*.

In the play it is in a sense only a matter of time, of the time that must elapse before Leontes' madness runs its course, of his time of repentance, which is also the time in which Perdita is nurtured at the bosom of nature and the fulfillment of the Oracle prepared. It is a tale of winter and of the renewal that comes when winter recedes, the renewal of nature, which, like Perdita, comes forth as if returning from death, calling forth renewed life even from stone. As if by magic, the magic of this theatre of stone.

In a sense one could say that theatre is always of stone. For everything on stage has a certain sculptural character, even if submitted to time in a way that is alien to sculpture as such, the link to time and human action determining in the end the specific character of theatrical sculpture. Even the actors and actresses—indeed preeminently they—have a sculptural quality specifically determined by the link to time and action. They are, as it were, mobile statues[10] endowed with the gift of speech—stone brought to life and made to speak.

But what is striking about *The Winter's Tale*, even if not unusual in Shakespeare's plays, is the *doubling* that it involves. This structure is marked within the scene where it is most openly in play, at the point in the final scene where Hermione descends and Paulina says to Leontes:

10. "In one compelling sense, all actors and actresses are moving statues, breathing art, animated in part by the playwright, or the script, and in part by the audience's sympathy, its imaginative consent" (Cynthia Marshall, "Dualism and the Hope of Reunion in *The Winter's Tale*," *Soundings* 69, no. 3 [1986], 295).

> Do not shun her
> Until you see her die again; for then
> You kill her double.
>
> (V.iii.105–107)

The words are themselves double, the doubleness concentrated in the word *double*: for Leontes is being told that, should he shun Hermione, he would kill her a second time, yet also that he would kill the double that art has first brought forth ("he so near to Hermione hath done Hermione" [V.ii.99–100]), the double as which she has returned from the semblance of death, across the "wide gap of time" (V.iii.154).

In *The Winter's Tale* there is a doubling of drama as such: within the drama that which all drama as such carries out is itself enacted. The play abounds with lines that turn it back upon itself, recasting its action as a play within the play. As when Leontes, raging with jealousy, says to young Mamillius:

> Go, play, boy, play: thy mother plays, and I
> Play too; but so disgrac'd a part. . . .
>
> (I.ii.187–188)

Or, as when Camillo, advising Florizel how his flight with Perdita is to be carried out, assures him that it will be

> as if
> The scene you play were mine.
> (IV.iv.593–594)

And, as in the penultimate scene, in the description of Paulina's embracing the princess whose discovery has fulfilled the Oracle and brought the two kings and their children together there:

> The dignity of this act was worth the audience of kings and princes;
> for by such was it acted.
>
> (V.ii.79–80)

All the world's a stage: not the world beyond the stage, outside the play, for which the play would be a kind of metaphor; rather, the

world *of* the play, the world enacted in the play, enacted now as itself
a play. Yet, what is distinctive about *The Winter's Tale* is that the con-
summate play enacted in it is one in which stone comes to move and
speak, just as all drama, being performed on its sculpturally ani-
mated stage, brings mere statues to move and speak.

In bringing statues to move and speak on its sculptured scene,
theatre also produces another doubling. For the appearance of char-
acters on that scene, characters who move and speak, constitutes a
presentation: in the theatre something is presented, is brought to
presence in its double on stage, something that itself remains, as
such, absent. That which is presented—doubled on stage—is not
itself present, not present as itself, on stage. It is something remote,
something kept "lonely, apart," like the statue of Hermione (V.iii.18).
It is something either removed *from* having been at all or removed
by having been, by time. Except in the pure limit-case of utter si-
multaneity (in which, still, the presented would be remote from its
presentation on stage), theatrical doubling brings to presence some-
thing that is dead and gone, if it ever was at all, something *vorbei*,
decisively absent. Theatre brings it back, back to the light of day,
back to the domain of the living. Theatre lets it come forth in and
as its double. This coming forth can be thought as the mimesis with
which theatrical art supplements the coming forth of nature,
though mimesis, so thought, would need to be thoroughly differ-
entiated from the sense of mimesis as copying (*Nachahmung*) that
Hegel submits to critique.

With respect to this doubling too *The Winter's Tale* is distinctive.
For it is itself a presentation of that which all theatre as such ac-
complishes, namely, bringing back to life, letting what has been kept
"lonely, apart" come forth into the light of day. In this respect *The
Winter's Tale* becomes theatre of theatre, theatrical self-presenta-
tion, when in the final scene the stone, which the artist has brought
forth in the image of Hermione ("he so near to Hermione hath
done Hermione" [V.ii.99–100])—this stone comes to life, comes
back to life across the "wide gap of time." Securing and sheltering
what is to come forth, stone can be shaped by art in such a way as
to bring back those who are dead and gone, calling them back as
do gravestones, but more powerfully when empowered also by the

magic of theatre, producing a simulacrum of rebirth in which the one who was dead and gone comes to move before one's very eyes, to speak, and to embrace those from whom she has been "dissever'd" and to whom she has returned across "this wide gap of time" (V.iii.154–155). Such a scene requires the utmost imagination from its spectators, not the lame fancy that would fill in the gaps left by a weak production,[11] but the strong-winged imagination capable of hovering between presence and absence so as to take part in the powerful movement of return. This movement is one of coming forth, produced by a second nature more powerful than nature itself, by an art made of nature and yet added to it, beyond it, so as to bring back, as if by magic, what nature itself—if there be a nature itself—could never call forth.

But it is a matter not only of the power of theatre but also of its beauty. Theatre is distinctive in the way it displays the character of the beautiful, the doubling involved in the shining forth of the idea, in the sensible shining of the intelligible. Heidegger underlines the way in which *Schein* is involved, indeed is at stake, in drama, specifically in Greek tragic poetry. Here, says Heidegger, the unity and conflict of being and shining are presented in the most elevated and pure manner. Both the unity and the conflict are rooted in the way that—if thought at the limit—shining belongs to being, in the way that—as thought by the Greeks—φαίνεσθαι belongs to φύσις or φύειν. Shining, appearing in the sense of self-showing, is not something subsequent (*Nachträgliches*) that sometimes may happen to being; rather, says Heidegger, being essentially unfolds as appearing ("Sein west *als* Erscheinen"),[12] opening a region in which, at one and the same time, beings can come forth *and* show themselves, shine forth. Yet, in the very shining that belongs to being there lies also—in the word but also in the phenomenal dynamics—the possibility of semblance (*Anschein*) in which what comes forth to show

11. "Much has been said about the final scene: it is, and—although with dissentient voices—has always been held to be, a scene of great power and beauty and is pre-eminently one which can only be fully appreciated when performed" (J. H. P. Pafford, Introduction to *The Winter's Tale*, Arden edition, lxii).

12. *Einführung in die Metaphysik*, vol. 40 of *Gesamtausgabe* (Frankfurt a.M.: Vittorio Klostermann, 1983), 108.

itself also withholds itself, shining forth, therefore, as other than it is. Heidegger cites the example of *Oedipus Tyrannos*: what is played out here, from the radiant beginning to the gruesome end, is the struggle between shining and being, between concealment and unconcealment. At the outset Oedipus, manifest in his radiance, sets about to reveal the secret by which the city is beset, that of the murderer of Laius: "Step by step he must place himself into unconcealment, which in the end he can bear only by putting out his own eyes; i.e., by removing himself from all light, by letting the cloak of night fall around him, and, as a blind man, crying out that all doors are to be opened in order that such a man may become manifest to the people as what he *is*."[13]

And yet, it is not only a matter of the shining that belongs to being and of the playing out of their conflict as it occurs in what is presented by drama. Rather, it is also a matter, in theatre, of a shining (appearing, self-showing—also semblance) that is, as it were, added to the words of dramatic poetry. In theatre it is never simply a matter of words and meanings, of words signifying meanings without further ado; in theatre there will always be much ado about such nothings as shine forth, presenting themselves on stage as if they were not mere nothings, as if they were everything, the entire world of the drama. Like the nothings of which Leontes speaks at one of the points in *The Winter's Tale* where this shining is turned back into the drama itself:

> Is whispering nothing?
> Is leaning cheek to cheek? is meeting noses?
> Kissing with inside lip? stopping the career
> Of laughter with a sigh . . . ?
>
> is this nothing?
> Why then the world, and all that's in't, is nothing,
> The covering sky is nothing, Bohemia nothing,
> My wife is nothing, nor nothing have these nothings,
> If this be nothing.
>
> (I.ii.284–296)

13. Ibid., 114.

One could regard Artaud's manifestos on the theatre as raising precisely the question of such shining. For instance, when he asks: "How does it happen that in the theatre, at least in the theatre as we know it in Europe, or better in the Occident, everything specifically theatrical, i.e., everything that cannot be expressed in speech, in words, or, if you prefer, everything that is not contained in the dialogue . . . is left in the background?" He names that which is specifically theatrical, that which has been marginalized by the orientation to speech: "music, dance, plastic art, pantomime, mimicry, gesticulation, intonation, architecture, lighting, and scenery"—in short, everything "apart from text."[14] What Artaud proposes borders sometimes on a sheer reversal of the opposition between the text and these other components, which he gathers under the phrase *mise en scène*: "it is the *mise en scène* that is the theatre much more than the written and spoken play."[15] At other times his proposal hints at a more complex strategy that would displace the opposition for the sake of a theatre situated beyond such duality of text and *mise en scène*: "it is essential to put an end to the subjugation of the theatre to the text and to recover the notion of a kind of unique language half-way between gesture and thought."[16]

But Artaud's strategy, while serving to bring the duality to light precisely in reversing or displacing it, is not that of Greek drama nor of Shakespearean theatre, where the duality of text and *mise en scène*, of words and their meanings over against shining, remains intact and utterly effective.[17] The shining forth in scenery, lighting, gesture, intonation, etc. is as nothing, merely added to exemplify, to let shine forth *sensibly*, what is said and what thereby is meant.

14. Antonin Artaud, *The Theater and Its Double*, trans. Mary Caroline Richards (New York: Grove Press, 1958), 37, 39, 40.

15. Ibid., 41.

16. Ibid., 89.

17. Although Artaud charges Shakespeare with responsibility for the "aberration and decline" of theatre, the charge is not directly linked to neglect of the specifically theatrical components. If theatre is in decline, "it is because we have been accustomed for four hundred years, that is since the Renaissance, to a purely descriptive and narrative theater—storytelling psychology; it is because every possible ingenuity has been exerted in bringing to life on the stage plausible but detached beings, with the spectacle on one side, the public on the

And yet, it is everything, the drama itself as performed there in the
theatre where even the seemingly dead words of the text come to
life in the voice of the characters on stage, fusing with the gestures
and intonations, ceasing to be anything other than what is given
voice there on stage, in the shining that theatre *is*. Nothing else. To
theatre, to its double character as word and shining, there belongs
the same duplicity that belongs to the beautiful itself in its character
as being shining forth amidst the sensible. It is this duplicity that
makes it possible for the shining to be also turned back into the text
and reflected there, as in Leontes' discourse on nothings.

Coming back, then, to *The Winter's Tale*, calling upon it as an
example of poetic discourse, it is not only its character as discourse
that I want to mark. It is not a matter of passing through its
signifiers to the complex of meanings that they signify, granting
perhaps a certain density to the signifiers that would distinguish
them from those found in a classically defined philosophical text,
but nonetheless in the end leaving them behind in order to confirm
at the level of meaning a certain identity with the philosophical (or
liminally philosophical) discourses that I have reconfigured from
Hegel and Heidegger. In setting a poetic discourse apart, it is a mat-
ter, not just of demonstrating a certain density, opaqueness, or in-
direction of its signifiers, but also, especially in the case of theatre,
of marking the shining that belongs to that discourse and consti-
tutes even its beauty. The shining, perhaps even more than the char-
acter of the literary signifiers, will serve to interrupt the passage to
meaning and to secure the irreducibility of the poetic discourse.

Thus, it is not just a matter of reading *The Winter's Tale*. Above
all, it is not a matter of translation, of carrying out a transition from

other—and because the public is no longer shown anything but the mirror of
itself. Shakespeare is responsible for this aberration and decline, this disinterested
idea of the theater which wishes a theatrical performance to leave the public in-
tact . . . " (ibid., 76). This is a curious charge, curiously similar to the one that
Nietzsche, in *The Birth of Tragedy*, brought against Euripides, in utmost contrast
to his praise for Shakespeare: "Shakespeare the poet of fulfillment, he brings
Sophocles to completion, he is the music-practicing Socrates" (*Nachgelassene
Fragmente* [Herbst 1869 bis Herbst 1872], vol. III 3 of *Werke: Kritische Ge-
samtausgabe*, ed. Giorgio Colli and Mazzino Montinari [Berlin: Walter de
Gruyter, 1978], 201).

the words of the play to what they mean, leaping perhaps from what is merely said to what the play really means, to what it means to say but does not quite say, to what, after having made the leap, the reader would then have said. One wonders indeed whether such a leap could ever be anything but simply another saying, a reinscription that would risk totalizing the polyphony of the dramatic discourse, reducing it to a discourse determined by the classical canons of philosophical discourse. To read thus by translating would risk replacing the poetic, dramatic discourse with a philosophical discourse. To say nothing of the reduction that it would not just risk but inevitably produce: the reduction, the exclusion, of the shining that in theatre is everything and nothing.

There is need, then, for a double interruption of the translation to meaning, of the transition from dramatic work to philosophical text. One interruption is to be produced by marking the shining of the theatrical work; this nothing can be most legibly marked in those examples in which the shining is also turned back into the discourse and reflected there in its duplicitous relation to the discourse—for example, in such theatre of theatre as one finds in *The Winter's Tale*. But aside from the shining, there is need also to interrupt translation by reading in a way that grants the polyphony of dramatic discourse and the sensible and elemental density of the literary signifier.

Both the polyphony of the discourse and a certain sensible density of the signifiers are linked to the character of drama as presenting human actions. One recalls in this connection the classical conception of drama as mimesis of actions (μίμησις πράξεως, in Aristotle's phrase); this conception remains fully in force in Hegel's *Aesthetics*, which characterizes drama in general as "the presentation of human actions and affairs in their presence and therefore of persons expressing their action in words." Dramatic action, Hegel stresses, is never a simple accomplishment of aims but rests on the complications into which action is led, on "the collisions of circumstances, passions, and characters."[18]

18. See Aristotle, *Poetics* 1449b. In Hegel's formulation one should note especially the doubling of presence marked by his use of both *Darstellung* and

Thus constituted, drama is, says Hegel, "the highest stage of poetry and of art in general." He links the superiority of poetry as such to the fittingness of its material: "For in contrast to the other sensible materials, stone, wood, color, and tone, speech alone is the element worthy of the expression of spirit." Dramatic poetry, in particular, he regards as supreme because of the way it unites the other genres, the objectivity of epic with the subjective character of lyric: "It presents complete action in its immediate presence both as actually arising from the interiority of the characters who bring it about and as an action whose result is decided by the substantial nature of the aims, individuals, and collisions involved" (*A* 2:512f.).

But is it certain that the language of drama moves at the level of synthesis that would make it uniquely expressive of spirit? Or does its polyphony and the collisions of voices and of actions resist, at least in certain instances, being brought under the unity of an *Aufhebung*? Furthermore, one cannot but wonder whether, precisely because drama presents action *in its immediate presence*, drama does not diverge from, rather than unify, epic and lyric, diverging thus from all other genres of poetry. Does drama not in the end diverge from poetry as such? For drama is not confined to speech as its material but rather—if not just read but performed and beheld in the theatre—also shines forth sensibly, even its language being voiced, sounded, while fusing with gestures and intonations within the radiant configuration that shines forth from the stage. If drama is, as Hegel says, "the highest stage of poetry and of art in general," then one may well wonder whether its superiority lies in its being purely linguistic and synthetic or whether its elevation stems primarily from the way in which drama, presenting action in its immediate presence, interrupts the operation of pure poetry, adding to the words and meanings a shining, the very element of the beautiful, everything and nothing.

In *The Winter's Tale* the shining that characterizes drama is turned back into the poetry in such a way that the double character,

gegenwärtig and further compounded or at least intensified by his use of a form of still another word (*vorstellen*) inseparable from what I am calling—without differentiation—presence: "die Darstellung gegenwärtiger menschlicher Handlungen und Verhältnisse für das vorstellende Bewusstsein" (*A* 2:513).

the mutual bearing of saying and shining, is reflected there. Indeed, within the play, in the course of its poetry, there is a dramatic interplay between saying and shining (in its range of senses from appearing or self-showing to semblance, in which concealment and its compoundings come into play). In the course of this interplay there is a certain development, which constitutes an essential moment of the drama and which itself would, in turn, shine forth in the theatre, a shining coming to double the interplay of saying and shining reflected within the poetry. The pivotal point of the entire development, indeed of the entire play,[19] comes with the reading of the Oracle's pronouncement; for it is at that point that all the concealments in which Leontes' jealousy had entangled him fall away so as to let things appear as they are. Almost as at the end of a tragedy. Almost as if the words of Apollo had brought the return of light, banishing finally the dark days of winter when even what is brightest serves only to cover and conceal, ushering in now the clear, warm days of summer.

The oracle to which Leontes appeals is called that of Delphos. It is "to sacred Delphos, to Apollo's temple," that he sends Cleomenes and Dion (II.i.183). One might suppose that the oracle at Delphi is meant, were it not that Cleomenes refers to it as an "isle" (III.i.2). In *Pandosta* too there is reference to "the Isle of Delphos."[20] It seems that in the early seventeenth century Delphos referred to the island of Delos, not without producing some confusion between the birthplace of Apollo (where also there was indeed a temple of Apollo) and the site of his most famous oracle, the supreme oracle of Greece.[21] But whether to Delos or to Delphi, the most decisive flight of the play, the flight that sets its very pivot in place, is a flight to Greece, the flight from Sicilia to Greece and back. And yet, in the time of the oracles, whether at Delphi or on Delos, Sicilia was itself *also Greek*, so that one might say that the flight to and from the oracle is no flight at all but a sojourning in Greece. The primary site of the play is Greece, and its flights are between Greece and

19. See Pafford, Introduction, lviii.

20. *Pandosta* is included as Appendix IV in the Arden edition of *The Winter's Tale*. For the reference to "The Isle of Delphos," see 195.

21. See Pafford's note in the Arden edition of *The Winter's Tale*, 54.

Bohemia, lying to the north and—notoriously—portrayed as having a coast. One will wonder of course about this Greece of the play, as Heidegger wondered about Goethe's experience of Greece in Sicily. One will wonder whether, as Heidegger wondered in the case of Goethe, it is not essentially a Roman-Italian view of Greece, seen in the light of modern—in this case Renaissance—humanism. One will wonder even further whether it is not, from beginning to end, an *anglicized Greece* that is presented by Shakespeare, something very remote from the originary Greece that Hölderlin's poetry opened to Heidegger. One could decide—if at all—only through the most attentive receptiveness to the play itself. But even in advance one may muster some expectation of originary access—despite or even through all the superficial anglicizing—if one takes to heart what Hegel says of Shakespeare's artistic nationalism: "Shakespeare understood how to imprint an English national character on the most variegated materials, although he knew how to preserve in its essential basic traits the historical character of foreign nations, as, for example, the Romans" (*A* 1:269). And yet, beyond the national character, it is a question of access to the sources that determined such character, to φύσις, to the ῥιζώματα, as they shone forth to the Greeks.

In *The Winter's Tale* the major axes are elemental and give to its language a certain elemental density. The axes involve pairings of opposed elements, of the elements that in their very oppositions are the roots of all things, providing all things with sustenance and delimiting the regions in which things can come up into the light, come forth into presence, the regions of the coming and going of what is, of what will have been. Among these elements there is, first of all, that very coming and going itself as it pertains most elementally to human beings. There is scarcely anything in *The Winter's Tale* that does not turn on the axis of birth and death, but the axis itself is best put in words at the point where Leontes' infant daughter, abandoned on the shore of Bohemia, has just been discovered by the old shepherd at the very same time that his son has witnessed the destruction both of Antigonus, who had left her there, and of the ship, in which he had brought the infant to Bohemia. The words are the shepherd's:

Heavy matters! heavy matters! But look thee here, boy. Now bless
thyself: Thou met'st with things dying, I with things new-born.

<div align="right">(III.iii.111–113)</div>

The same scene puts prominently into play another pair of ele-
ments: earth and the heavens, especially as they can reflect events
pertaining to birth and death, for example, such sinister events as
leaving a newborn to die in the wild. As they land with the babe,
the mariner assures Antigonus that they have reached "the deserts
of Bohemia":

> Ay, my lord, and fear
> We have landed in ill time: the skies look grimly,
> And threaten present blusters. In my conscience,
> The heavens with that we have in hand are angry,
> And frown upon 's.

<div align="right">(III.iii.2–6)</div>

Recalling the dream in which Hermione's ghost appeared to him,
Antigonus reasons,

> that
> Apollo would, this being indeed the issue
> Of King Polixenes, it should here be laid,
> Either for life or death, upon the earth
> Of its right father.

<div align="right">(III.iii.42–46)</div>

And then, just as he is about to be done in by the bear:

> The day frowns more and more: thou 'rt like to have
> A lullaby too rough: I never saw
> The heavens so dim by day.

<div align="right">(III.iii.54–56)</div>

It is in relation to these elements, earth and the heavens, that a
certain disturbance is first announced, not a mere reflection of sin-
ister events, but a divergence, a contamination, an interruption, po-
tent enough to disturb the simple symmetrical opposition between
the two elements. Leontes has just declared Hermione an adultress.
She tries to gentle him by speaking of the grief that he will suffer

over this denunciation once he comes "to clearer knowledge." Leontes replies:

> No: if I mistake
> In those foundations which I build upon,
> The centre is not big enough to bear
> A school-boy's top. Away with her, to prison!
> (II.i.100–103)

In his delusion Leontes thinks the foundation of his actions—denouncing Hermione and now sending her to prison—are so secure that for them to prove otherwise would be tantamount to the centre, the earth, losing all capacity to support, losing what is proper to it, suffering utter contamination, becoming, as Antigonus will soon say to Leontes, a "dungy earth" (II.i.157). Hermione's response draws the opposite element into the sphere of disturbance:

> There's some ill planet reigns:
> I must be patient till the heavens look
> With an aspect more favorable.
> (II.i.105–107)

Up to this point, on the other hand, the other elements are assembled in their undisturbed symmetrical opposition. In the very first scene, for example, Camillo mentions that "this coming summer" Leontes will pay Polixenes the visit owed him (I.i.5). At that time, indeed throughout the entire first part of the play, it is winter, as is revealed by Mamillius' remark:

> A sad tale's best for winter.
> (II.i.25)

Thus, the play proves to have begun with a look ahead from winter to summer, following thus the natural alternation of seasons, their simple symmetrical opposition being paired, in turn, with that of mutual visitation. These alternations and the separations they involve are described as almost natural outgrowths of the time of childhood innocence, when Leontes and Polixenes were constantly together and oblivious to temporal differentiation. Polixenes says, speaking to Hermione before Leontes' jealousy comes into play:

> We were, fair queen,
> Two lads that thought there was no more behind,
> But such a day to-morrow as to-day,
> And to be boy eternal.
>
> (I.ii.62–65)

It is as if the alternation of the seasons and of visitations to each other were only an extension into their maturity of the unity enjoyed in their youth.

It is almost the same with birth and death, Polixenes speaking of the nine months spent in Sicilia:

> Time as long again
> Would be fill'd up, my brother, with thanks.
>
> (I.ii.3–5)

Likewise with Hermione's lady, looking ahead to the expected birth:

> we shall
> Present our services to a fine new prince
> One of these days.
>
> (II.i.16–18)

And, even though occurring in the aside in which Leontes first gives voice to his jealousy ("Too hot, too hot"), the first reference to death sets it apart, at a distance where it cannot yet contaminate or interrupt the smooth course of things. It is death in another tongue and the death of an animal:

> and then to sigh, as 'twere
> The mort o' th' deer.
>
> (I.ii.117–118)

However, everything changes once death or its semblance comes into play, once Paulina announces the most monstrous consequence of Leontes' tyrannical jealousy, once she reports that Hermione is dead and offers Leontes nothing but the imperative:

> therefore betake thee
> To nothing but despair.
>
> (III.ii.209–210)

From then on it will be, says Paulina, "still winter" (III.ii.212)—that is, always winter, perpetual winter, the monstrosity of Hermione's death being so great that it will disturb, indeed interrupt from then on, the natural alternation of the seasons and never again—so she forecasts—allow the hope that comes when winter begins to recede and spring comes to announce the warm, clear days of summer.

It is not long before time itself arrives on the scene, speaking as the chorus. Time tells of a certain progression: it has not remained perpetual winter and in the figure of Perdita, "now grown in grace" (IV.i.24), it would seem even to announce a coming of spring. And yet, time comes upon the scene precisely in order to tell of an interruption, to say, in the voice of time:

> Impute it not a crime
> To me, or my swift passage, that I slide
> O'er sixteen years, and leave the growth untried
> Of that wide gap.
>
> (IV.i.4–7)

Yet, time's intervention, restoring progression but also interrupting it, does not have the effect of undoing the disturbance wrought by the monstrosities stemming from Leontes' jealousy. Time's intervention does not simply restore the symmetrical opposition between the elements so as to make it a matter of simple opposition between winter and its overcoming through the arrival of spring, between the short, cold, dark days of winter and the long, warm, bright days of early summer.

Autolycus enters, singing:

> *When daffodils begin to peer,*
> *With heigh! the doxy over the dale,*
> *Why then comes in the sweet o' the year,*
> *For the red blood reigns in the winter's pale.*
>
> (IV.iii.1–4)

Autolycus sings, it seems,[22] of spring. His song seems to announce within the movement of the play the end of the endless winter fore-

22. Certainly the reference to daffodils—later classed with the "flowers o' th' spring" by Perdita (IV.iv.113, 118–120)—as well as the line "Why then comes in the sweet o' the year" evoke spring. The line "For the red blood reigns in the

cast by Paulina. And yet, speaking of his mythical namesake, Autoly-
cus describes him as one

> who, being as I am, littered under Mercury, was likewise a snapper-
> up of unconsidered trifles.
>
> (IV.iii.24–26)

Autolycus is a thief, like Mercury the father of his namesake; he is a
petty thief, one whose "traffic is sheets" (IV.iii.23). But Mercury was
also a liar,[23] and the Autolycus of the play no less so. One kind of
thing that he tricks the rustics into buying at the sheep-shearing fes-
tival is "counterfeit stone" (IV.iv.598); in passing it off as genuine,
he lies as does the stone itself and at the same time steals from the
rustics who innocently pay as if it were genuine. Later, as Florizel
and Camillo exit on their separate ways to Sicilia, Autolycus reveals
himself to the audience as one whose very calling is to conceal. If he
thought it honest to inform the king of their intent,

> I would not do 't: I hold it the more knavery to conceal it; and
> therein am I constant to my profession.
>
> (IV.iv.681–683)

And still later, as he is about to speak to the shepherd and his son,
Autolycus says in an aside:

> Though I am not naturally honest, I am so sometimes by chance.
>
> (IV.iv.712–713)

But the occasion when he sings of spring is not one of those chance
times. His song of the arrival of spring is a lie.[24]

This is borne out in the sheep-shearing festival, which follows

winter's pale" is more complex and the word *pale* has been variously glossed.
While it can refer to the paleness of complexion caused by winter or the enclo-
sure required during this season, the context would seem to require that it also
refer to winter's loss of intensity as it recedes with the coming of spring. This
play of obliquely opposed meanings might be regarded as reflecting the same
duplicity that is found in Autolycus himself.

23. Plato has Socrates describe Hermes as "a deceiver in speeches [τὸ
ἀπατηλὸν ἐν λόγοις]" (*Cratylus* 408a).

24. It would be most apt to apply to Autolycus the remark that Hegel makes
regarding Shakespeare's characters in general, that Shakespeare "equips them
with a wealth of poetry" and "gives them spirit and phantasy: by the image in

shortly and for which—in the same scene in which Autolycus sings of spring—the shepherd's son was on his way to buy provisions. During the festival Perdita identifies the time of year:

> Sir, the year growing ancient,
> Not yet on summer's death nor on the birth
> Of trembling winter. . . .
>
> (IV.iv.79–81)

It is not spring but late summer, perhaps even summer's extension into early autumn. At the festival there are flowers of winter:

> there's rosemary, and rue; these keep
> Seeming and savour all the winter long.
>
> (IV.iv.74–75)

There are also still some "flowers of middle summer" (IV.iv.106–107), and Perdita gives the disguised Polixenes and Camillo both flowers of winter and those of middle summer, mixing the seasons. But Perdita has no flowers of spring to give—"I would I had some flowers o' th' spring" (IV.iv.113)—for their time is long past and they do not last: "O, these I lack" (IV.iv.127).

Once time interrupts so as to restore progression and end the endless winter that Paulina had forecast, it is as if that progression drove what would be opposed to winter on past the point of symmetrical opposition. What is opposed to the dead of winter is neither spring with its rebirth of nature nor early summer with its long, warm, bright days. Even if it is "not yet on summer's death," even if the progression has not yet come back around to "the birth of trembling winter," the year has grown ancient, and what is opposed to winter is not summer as such but the waning of summer.

In the discussion that Hegel devotes in the *Aesthetics* to the dramatic work of art, to drama as a concrete work of art, he focuses primarily on the unity of drama and on the way drama is divided

which, through theoretical intuition, they can contemplate themselves like a work of art, he makes them free artists of their own selves, and thereby, with his strongly marked and faithful characterizations, knows how to interest us not only in criminals but even in the most common and vulgar clouts and fools" (*A* 2:577).

and unfolds through those divisions. Regarding the latter he appeals to Aristotle's classical prescription that there must be a beginning, a middle, and an end. On this basis he maintains that a drama best suits its subject matter—human actions in their collisions—if it is divided into three acts: "In the *first* the emergence of the collision is explained, which then in the *second* appears in animated form as the clash of interests, as difference, struggle, and complication, until finally, in the *third*, when contradiction is at the peak, it finds its necessary resolution" (*A* 2:524). It is precisely the unity of this unfolding—from the emergence of clashing interests to their collision, their contradiction, to their final resolution—that Hegel regards as the primary unity to be exhibited by the dramatic work of art, a unity of much greater significance and determinacy than the unity of place and of time. It is especially notable how Hegel describes the final moment in which the unity of the dramatic work would be fulfilled: at this point, in this moment that would bring the dramatic work to completion, the contradictions that will have broken out in all the negativity of difference come to be *aufgehoben*. Through the work of determinate negation there is power to turn nothing into being, death into renewal of life. Because such power is brought into play, Hegel underlines the need, at the conclusion of a drama, for "the whole thing to be closed and finished off" (*A* 2:521). This applies, says Hegel, not only to Greek drama but also to modern plays, which, with their subplots and incidental characters, display a looser unity than in the case of Greek tragedy. Hegel mentions some examples from Shakespeare, among them the ending of *Hamlet*: "Similarly in *Hamlet* the fate of the Kingdom of Denmark remains merely a subordinate interest, but nonetheless it is taken into account by the entry of Fortinbras and receives its satisfactory conclusion" (*A* 2:521f.).

But *The Winter's Tale* violates the Hegelian prescription. Not because, as always in Shakespeare, it is formally divided into five acts or because it resists division into three parts. On the contrary, from both a topological and a dramatic point of view, there is good reason to divide the play into three parts. The first part takes place in Sicilia in winter and concludes at the trial of Hermione with the three devastating blows that finally break through Leontes' mad-

ness: first, the pronouncement of the Oracle, then the news of
Mamillius' death, and finally the announcement that Hermione too
is dead. The second part takes place in Bohemia, and, though its
time is discontinuous, time interrupting to announce a sixteen-year
interruption, most of this part occurs in the waning of summer.
The third part begins with Paulina's invocation of the Oracle's pro-
nouncement and of the suspension in which it holds Leontes; the
action is again in Sicilia, to which finally all return.

But, though the play divides thus into three parts, these parts do
not correspond at all to the schema proposed by Hegel. One could
almost say that all three moments of the Hegelian schema occur in
the first part of *The Winter's Tale*: by the time Hermione's trial oc-
curs, the dramatic contradiction (most notably, Hermione's inno-
cence and dignified bearing as she endures Leontes' raving jealousy
and the charge and threats to which it gives rise) is at the peak, and
the three blows that finally overwhelm Leontes bring the first part
of the play to an end that is like the end of a tragedy, that would
perhaps be indistinguishable from such a tragic end were it not for
the suspension produced by the short scene (with Cleomenes and
Dion returning from Delphos) that just precedes that of the trial[25]
and especially by the hope held out in the Oracle's pronouncement.
Paulina invokes that hope at the beginning of the third part:

> For has not the divine Apollo said,
> Is 't not the tenor of his Oracle,
> That King Leontes shall not have an heir,
> Till his lost child be found? which, that it shall,
> Is all as monstrous to our human reason
> As my Antigonus to break his grave
> And come again to me.
>
> (V.i.37–43)

Hermione herself recalls this hope at the end of the play, by which
time, however, it is manifest that, though the lost child has been
found, Antigonus will not break his grave and return. After the
tragic ending of the first part, suspended only to the extent required
for opening onto the rest of the play, it does not become a matter

25. See Pafford, Introduction, lviii.

simply of a fulfillment symmetrically opposed to the tragic ending. But fulfillment there is, even if obliquely opposed to the tragic ending of the first part. There is also, in the second and third parts, a great deal of comedy: the antics of Autolycus,[26] the play of disguises, the rustics comporting themselves as "gentlemen born" (V.ii.128), the weddings that are to be celebrated but that, at the end of the play, have not yet begun. Deferred nuptials, marriages still to be consummated, promises still to be fulfilled.

In the third part of the play the time is continuous with that of the sheep-shearing festival. Indeed, when Florizel and Perdita appear at the court in Sicilia, Leontes exclaims:

> Welcome hither,
> As is the spring to th' earth.
> (V.i.150–151)

But Florizel is lying to Leontes, lying outright about the purpose of his flight to Sicilia and about the situation of Perdita. The spring that Leontes welcomes is a false spring. For the season is late summer or early autumn, the time neither of the overcoming of winter nor of winter's opposite; it is the time of the waning of summer.

In *The Winter's Tale* determinate negation does its work, does it, in a sense, more thoroughly than in tragedy, for instead of turning nothing into merely the promise of being, it holds open—beyond the tragic ending—a hope that comes to a certain fulfillment in the second and third parts of the play. The mad tyrant, shaken by the blows emanating from the Oracle, does not die but repents and finally has restored to him his daughter and his wife, both returning from the semblance of death. And yet, the fulfillment achieved serves to make all the more dramatically manifest the incompleteness. The more thorough work of the negative has the effect of exposing the limits of its power to turn into being, to turn death into renewal of life. Indeed, it is not even just a matter of incompleteness, some things hoped for not becoming actual; rather, it is a matter of irretrievable loss within the very fulfillment of the hope onto which the tragedy opens. Perdita is found, but Antigonus, lost with her, does not, as Paulina had hoped,

26. Pafford compares Autolycus with Feste (ibid., lxxx).

> ... break his grave
> And come again to me; who, on my life,
> Did perish with the infant.
>
> (V.i.42–44)

Thus it is that Paulina is both "elevated" and "declined":

> But O, the noble combat that 'twixt joy and sorrow was fought in
> Paulina!
>
> (V.ii.72–74)

Though Perdita returns finally, bringing King Leontes an heir to his
kingdom in the person of Florizel, the true heir Mamillius is dead.
And even if, at the end, all are together in Sicilia, Leontes will be
succeeded by a king from Bohemia, who will also be King of Bohe-
mia. The configuration is not dialectical: one from another land will
constitute the identity of Sicilia, will (eliding, as was customary, the
distinction between the king and his country) *be* Sicilia, but without
appropriation, since he will also *be* Bohemia. The identity of Sicilia
will be exposed to alterity; it will be an identity belonging to difference.

But, above all, time has passed, stealing away sixteen years of life,
irretrievably lost. It is time, above all, that interrupts and limits the
power of the negative. Leontes and Hermione are reunited only in
their old age, and their happiness is an autumnal happiness.[27]

But what of the shining of *The Winter's Tale*, its shining in *The
Winter's Tale*, as turned back into the discourse and reflected there
in relation to the discourse? What of saying and shining in *The Win-
ter's Tale*? What of their interplay and its development?

The pivotal point of the development, the invocation of the Or-
acle's pronouncement, is a double point, essentially dividing the play
into its three parts. Between those two points where the Oracle is
invoked, there is another, as distant as possible from the Sicilian
court, an imperative that provides something of a paradigm, an im-
perative voiced by the shepherd at the beginning of the sheep-shear-
ing festival, addressed to Perdita:

27. See ibid., lxx.

> Come, quench your blushes, and present yourself
> That which you are, Mistress o' th' Feast.
>
> (IV.iv.67–68)

Over against this imperative, what pervades the initial scenes of
the play is a condition for which Polixenes provides the expression:
"ignorant concealment" (I.ii.397). In those scenes virtually every-
thing turns on a complicity between that concealment and what is
said, said thus in ignorance. As when Leontes, having sent Hermione
off to prison, continues to denounce her to his Lords, projecting
ignorance upon Antigonus for counseling "silent judgment":

> How could that be?
> Either thou art most ignorant by age,
> Or thou wert born a fool. Camillo's flight,
> Added to their familiarity,
> (Which was as gross as ever touch'd conjecture,
> That lack'd sight only, nought for approbation
> But only seeing, all other circumstances
> Made up to th' deed) doth push on this proceeding.
>
> (II.i.172–179)

In place of the silence wished for by Antigonus, there is speech, de-
nunciation soon to be made openly in public. In place of sight and
of a showing open to sight, there is concealment. The concealment
is compounded: the true circumstances of Hermione and Polixenes
are concealed from Leontes by the very concealment that he fancies
he sees in their behavior. He cannot see because of what he thinks
he sees, because of

> . . . his opinion, which is rotten
> As ever oak or stone was sound.
>
> (II.iii.89–90)

He cannot see because, as Paulina also declares, he is blinded by his
"own weak-hing'd fancy" (II.iii.118).

With Hermione there is also concealment, but, with it, silence.
She is secured, sheltered, by the semblance of death. Persisting in
that concealment for sixteen years, she reappears finally as stone,
which is resistant to time, a sensible image of timelessness, even

though still submitted to time. It is as if she were preserved by means of stone, and it is from stone that she will be called back, as gravestones call back those who are dead and gone, who are "lonely, apart" (V.iii.18). As Hero, in her semblance of death, appears to Claudio's imagination more moving, delicate, and full of life, so does Hermione return to Leontes still more lovely. It is time to recall that, when in the *Phaedrus* Socrates speaks of the beautiful, he calls it not only the most shining (τὸ ἐκφανέστατον) but also the most lovely (τὸ ἐρασμιώτατον), the most evocative of love—as is Hermione, as she comes forth in the magical final scene.

It is also time to turn to that scene. But not before noting briefly how it is prepared for by the two scenes that precede, specifically as regards the interplay of saying and shining. The first of those scenes is at the court of Leontes, where Florizel and Perdita have appeared before the king. The scene is one of deception, Florizel lying to Leontes about the reason for his presence there, pretending to have come in Polixenes' behalf rather than in opposition to his father's will. Leontes is taken in and welcomes the couple as "the spring to th' earth" (V.i.151). But what is decisive is the way in which this scene of deception comes to be interrupted at the very point where Florizel's deceptive speech has proved most effective in duping the repentant king. A Lord enters announcing that Polixenes is in the city and setting mere speech in opposition to the proof that is about to appear:

> Most noble sir,
> That which I shall report will bear no credit,
> Were not the proof so nigh.
>
> (V.i.177–179)

The Lord reports also the truth, learned from Polixenes, about Florizel and Perdita, transforming the scene of deception into a quite different one.

In the penultimate scene everything is merely reported, merely *said*, and nothing enacted on stage, nothing *shown*. It is even said that what is reported must have been seen if one is to be able to speak of it. To one who did not see the events, it is said:

Then have you lost a sight which was to be seen, cannot be spoken
of.

<div align="right">(V.ii.43–44)</div>

The entire scene, preparing for the showing to come, is "so like an
old tale" (V.ii.28).

Imagine, then, the final scene, theatre of stone. Or better, re-
member it as once seen, the more vividly the better. Or still better,
remember it as if one were now, at this very moment, in the theatre
watching its performance.

Imagine Paulina drawing the curtain aside, letting the play
within the play begin, the shining of theatre in theatre. Picture the
stone, which Paulina has kept "lonely, apart" (V.iii.18). Picture it on
stage, remaining silent before it, feeling the wonder it evokes:

> I like your silence, it the more shows off
> Your wonder.

<div align="right">(V.iii.21–22)</div>

Leontes is invited to speak, Paulina asking him about the resem-
blance of the stone to Hermione, Leontes answering not by speak-
ing to Paulina but by speaking to the stone itself—

> . . . dear stone, that I may say indeed
> Thou art Hermione.

<div align="right">(V.iii.24–25)</div>

But Hermione, beautiful though she be, is wrinkled from the wear
of time, by the passage of sixteen years, which the artist has thus
represented in the stone.

Directing the performance, Paulina feigns concern lest Leontes'
fancy think the stone moves, lest he think too that it lives. But she
only feigns, concealing for the moment that she is playing the role
of stage director, offering to "afflict" her audience farther, soon
promising the very magic of theatre:

> Either forbear,
> Quit presently the chapel, or resolve you
> For more amazement. If you can behold it,

I'll make the statue move indeed; descend,
And take you by the hand: but then you'll think
(Which I protest against) I am assisted
By wicked powers.

 (V.iii.85–91)

The audience must awaken to the magic, call forth strong-winged
imagination, as the music begins and the stone comes to life:

 Music, awake her; strike!
'Tis time; descend; be stone no more; approach;
Strike all that look upon with marvel. Come!
I'll fill your grave up: stir, nay, come away:
Bequeath to death your numbness; for from him
Dear life redeems you. You perceive she stirs.

 (V.iii.98–103)

Not immediately upon her descent, but soon, seeing Perdita, she
speaks—invoking the gods' graces upon the long-lost one who has
returned, like herself, from semblance of death, speaking then to
Perdita, asking about her daughter's preservation, telling all she will
tell in the play about her own. For these are her last words:

 for thou shalt hear that I,
Knowing by Paulina that the Oracle
Gave hope thou wast in being, have preserv'd
Myself to see the issue.

 (V.iii.125–128)

Hardly an answer to the question that Polixenes has, at that point,
already raised as to

 . . . where she has liv'd,
Or how stolen from the dead!

 (V.iii.114–115)

It is Paulina who answers:

 That she is living,
Were it but told you, should be hooted at
Like an old tale: but it appears she lives.

 (V.iii.115–117)

The answer lies not in saying, at least not in saying alone, but in showing, in the sight of her living radiance. The play gives no other answer, no answer by which the whole thing would be closed and finished off. Hermione's concealment, how she was sheltered, remains itself sheltered, concealed. Like stone.

But now time has come to interrupt the poetry, to release the shining from the play, turning it out and putting the text aside, going off to the theatre.

JOHN SALLIS is W. Alton Jones Professor of Philosophy at Vanderbilt University. His previous books include *Phenomenology and the Return to Beginnings, Being and Logos, The Gathering of Reason, Delimitations, Spacings, Echoes: After Heidegger*, and *Crossings*. Sallis is editor of *Reading Heidegger: Commemorations* and founding editor of the journal *Research in Phenomenology*.